# MAINE: *Guess Where from the Air*

Copyright © 2007 by Charles Feil

Designed by Ernest A. Rose

ISBN-10: 0-89272-713-6
ISBN-13: 978-0-89272-713-1

5  4  3  2  1

Printed in China

Down East Books
Camden, Maine
A division of Down East Enterprise,
publishers of Down East the magazine of Maine
Book Orders: 800-685-7962
www.downeastbooks.com
Distributed to the trade by National Book Network

Library of Congress Cataloging-in-Publication Data

Feil, Charles, 1948-
    Maine : guess where from the air / photographs by Charles Feil ; text by Murad Sayen.
        p.    cm.
    ISBN-13: 978-0-89272-713-1 (trade pbk. : alk. paper)
    ISBN-10: 0-89272-713-6
    1. Maine--Aerial photographs. 2. Maine--Description and travel--Miscellanea.
    3. Maine--History, Local--Miscellanea. I. Saÿen, Murad. II. Title.
F20.F46 2007
974.1--dc22
                                                            2006038004

# MAINE: *Guess Where from the Air*

*Photography by Charles Feil ~ Text by Murad Saïen*

DOWN EAST BOOKS      *www.downeastbooks.com*

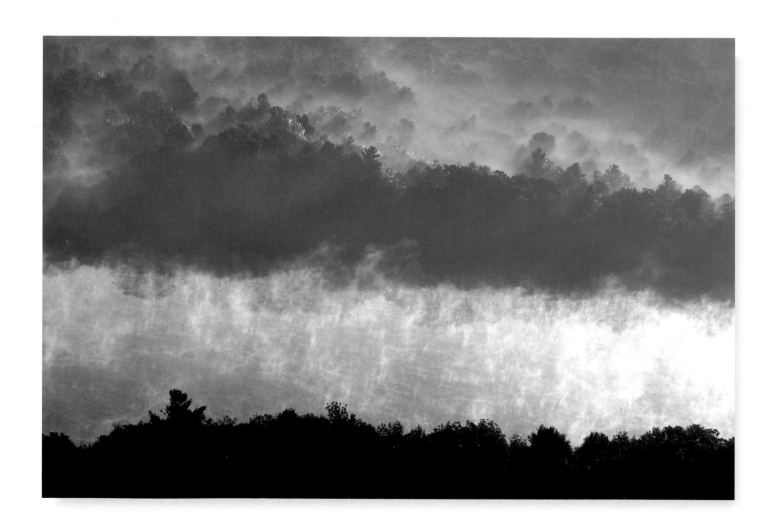

# CONTENTS

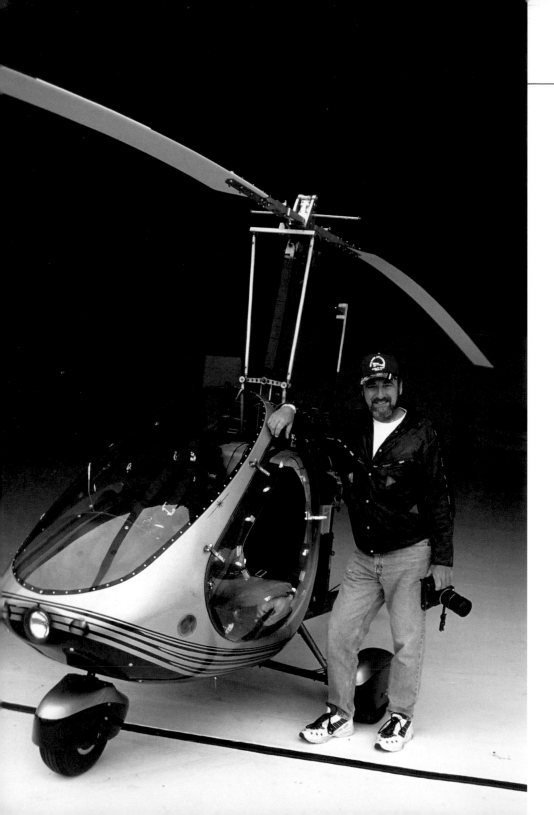

### ~ About the Photographer ~

Adventurer, aviator and author, Chuck has always believed that if you follow your passions the rest will fall into place. He has traveled five continents with his camera on his shoulder and a sense of adventure in his soul. Jane Goodall sought him out to make wildlife films on the Serengheti Plain of East Africa. Major publications and corporations appreciated his easygoing ways and ability to bring to the table dazzling photography. Being restless and never completely satisfied, Chuck "kicked it up a notch" by learning to fly and integrated it with his photography skills. In 1996 Down East Books published his first book, *Maine - A View From Above*, in what was to become a popular series. This is the eleventh coffee table book of aerial photography by Chuck Feil.

### Maine - Guess Where from the Air

This book is the result of a conversation between Chuck Feil, Murad Saÿen, and the editors of Down East Books. Building on the strengths of the "*Views From Above*" series, this book is designed to be interactive. It puts images that are both beautiful and yet somehow mysterious in front of the reader and challenges him or her to solve the puzzle presented by each one.

As you will discover, some of the puzzles have lots of clues. Others have a series of questions. Some questions are easy. Some are hard. The answers are at the back of the book. We hope you will let yourself become engaged with the process of identifying and naming the places depicted in the photographs and in answering the questions. Let's start with a little practice: What kind of aircraft is this?

Oh, sure, at first glance you want to say helicopter. If you are an aviation enthusiast you will know that this type of aircraft actually predates helicopters. In fact, in 1921, a Spaniard, Juan de la Cierva, made the first flying version. A French inventor, Etienne Oehmichen, didn't fly the first successful helicopter for another three years. Of course, Leonardo DaVinci had sketched the idea for so-called "rotary wing" aircraft back in the mid-1500s. He even built some small models, but without a compact and efficient source of power his efforts were doomed to remain grounded. It wasn't until the end of the nineteenth century that the invention of the internal combustion engine made powered flight a viable possibility.

If you look closely, you'll see that this bird has a propeller on the back of the engine. This pushes it forward through the air, and it is this movement that causes the overhead rotor to spin. It is also missing the so-called "anti-torque" rotor, a.k.a. tail rotor, that all single rotor helicopters must have in order to avoid spinning like a top when they are hovering. And, there is no power to the main rotor . . . none. It is freewheeling and provides lift as it spins from the forward motion of the aircraft.

*The question is what kind of aircraft is this?*

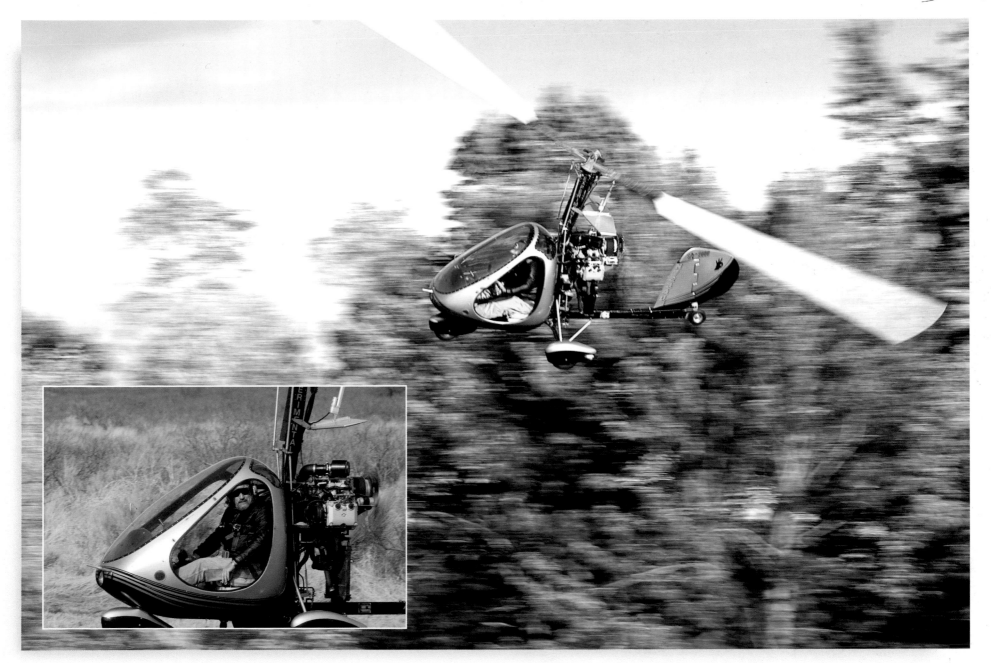

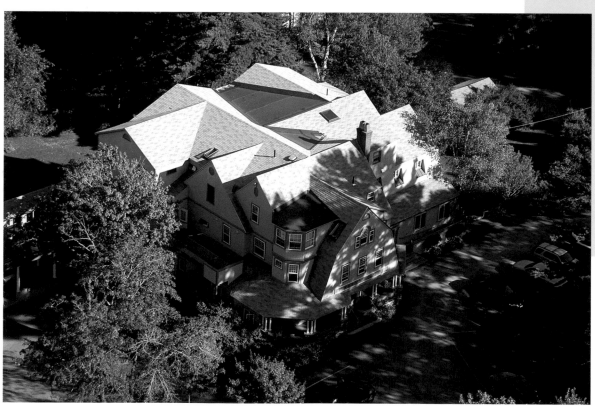

These images show not only a substantial and comely manor house, but also the fact that it is perched just yards from the Maine coast, in an area that doesn't appear to be developed at all. I was told that this stone edifice has 151 exterior windows, and the only architect-designed annex, with cupola, in Maine. A house of this stature usually has a name, and there may be just the slightest touch of Maine irony in naming a stone-built house "Roxmont," which could be loosely translated as "Rockpile."

Built in 1903 by the Havener family, it is no longer a private home, but has found a second life as a corporate headquarters. In fact, the company has been publishing for more than 50 years.

Your challenge is to name both the location of Roxmont, and the company whose staff members get to arrive here each workday morning.

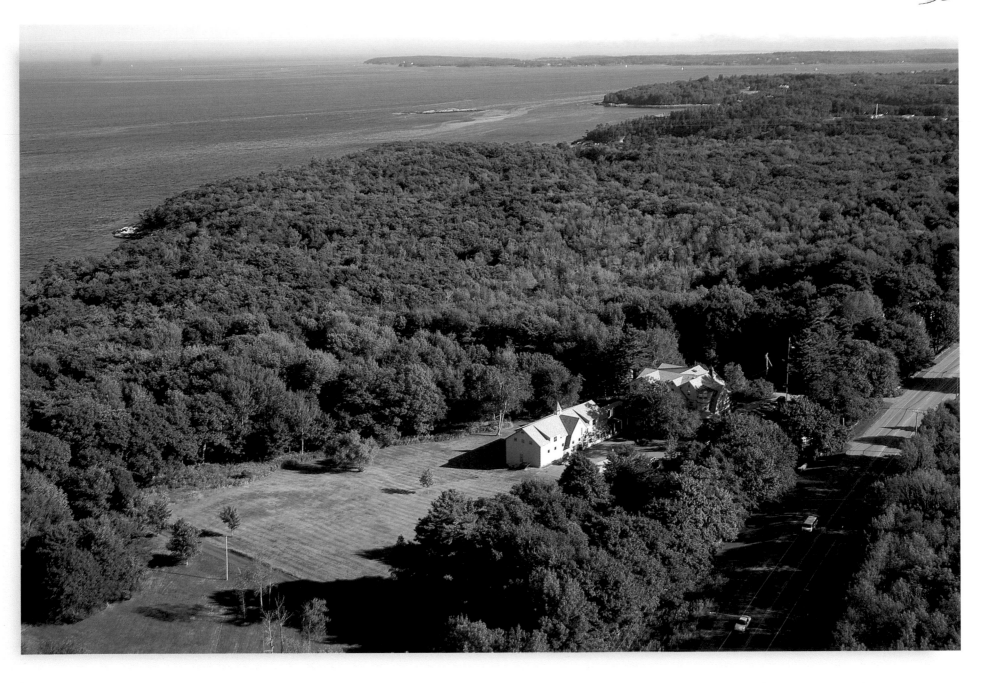

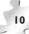

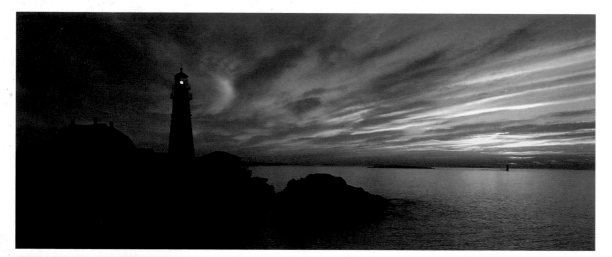

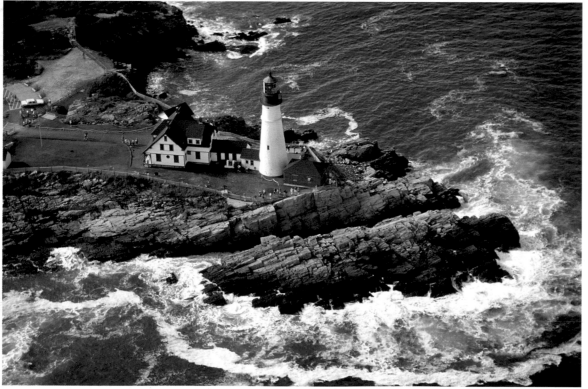

**O**nly a handful of lighthouses actually seem bigger than life. They become so extraordinarily well known because they are pictured in calendars, print and television advertisements, and on postcards and even postage stamps. Most people recognize them at a glance. This particular lighthouse is arguably the most famous in Maine, and is the oldest of all American lighthouses. It has been used as the backdrop for so many ads that it imparts a feeling of familiarity when it inevitably pops up again. In fact, it has been used in print and television spots by companies as far away as Japan and Europe.

Okay, yes, this mystery is pretty much a "gimme." But, perhaps there is more to the story than just knowing the name and location of this famous light. Did you know that Henry Wadsworth Longfellow used to travel out from Portland to sunbathe on the rocks beside this lighthouse, or that, according to one published guide, you can see twelve other lighthouses from this one?

An interesting aside: in 1852, members of the newly formed "Lighthouse Board," a federal agency, came to inspect this light and found, to their dismay, that the keeper had badly scratched the recently installed mirrors, and that this sterling fellow, John F. Watts, was blowing the fog horn only for those ships whose captains had made a paid contract with him to do so. All others got no signal. Flagrant selfishness, even by today's standards, don't you think?

Okay, what light is it, and who was the President that signed the bill authorizing its construction? And, the bonus question: what year did he do so?

> Here's a good hint:
> Maine was separated from Massachusetts in 1820,
> and this light was already in its third decade by then.

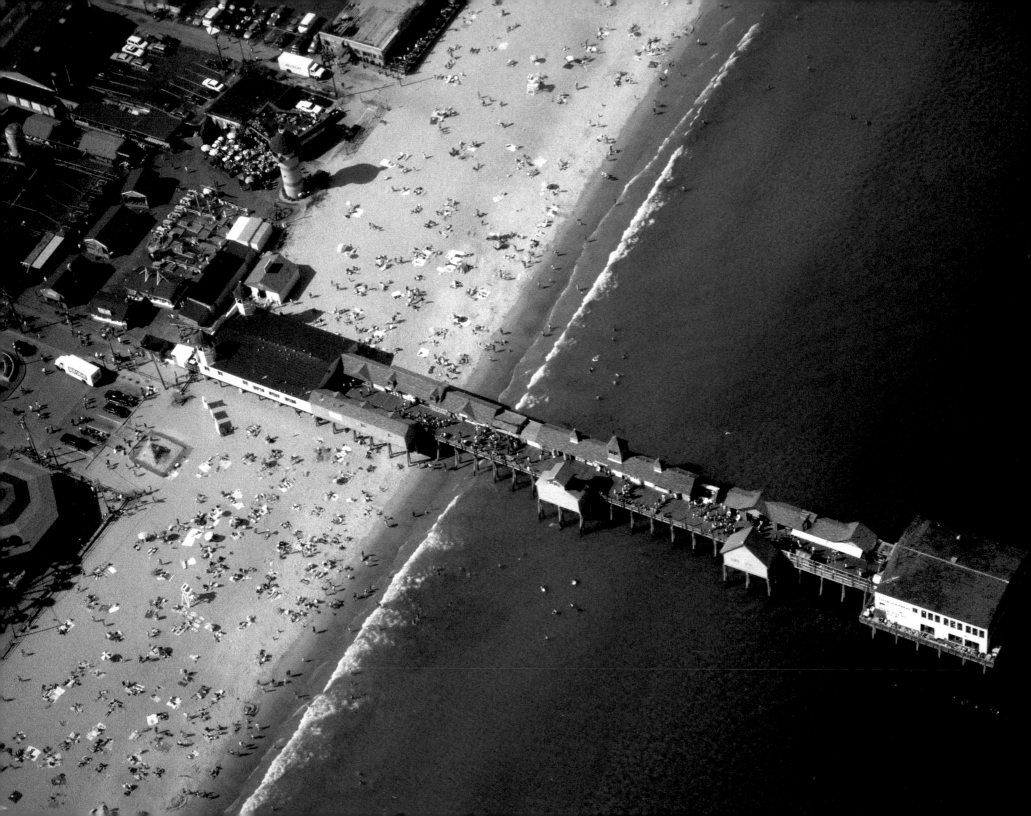

In a dance hall on this pier couples once danced the night away under a glittering crystal ball. It was such a popular place that it attracted the most famous big bands and crooners of their day, including Count Basey, Duke Ellington, Rudy Vallee, and many more.

The town where this pier is located was almost destroyed by fire in 1907, and it dates all the way back to 1653, when it was founded by Thomas Rogers. Its name comes from a landmark planted on a ridge and visible from ships at sea. The settlement was attacked by 150 Native Americans intent on wiping out the unwelcome interlopers, but managed to survive and is today one of Maine's most popular tourist destinations. The famed Grand Trunk Railway traveled from Montreal to this town and brought the first influx of summer visitors from Canada, a tradition that persists today. In fact, walking the streets here in season, one is as likely to hear French spoken as English.

In the late '20s, immediately after Charles Lindbergh's nonstop flight across the Atlantic, this place, with its wide and firm white-sand beach, became the leaping off spot for aviators also intent on setting records. It holds a place in the history of aviation for that reason.

*So what is the name of this tourist hot spot?*

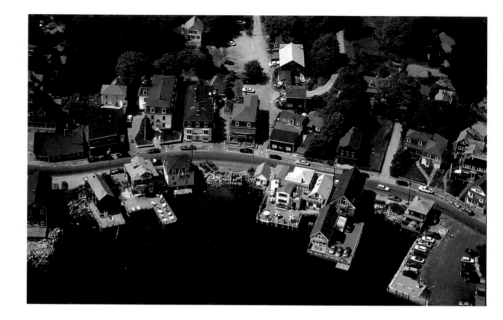

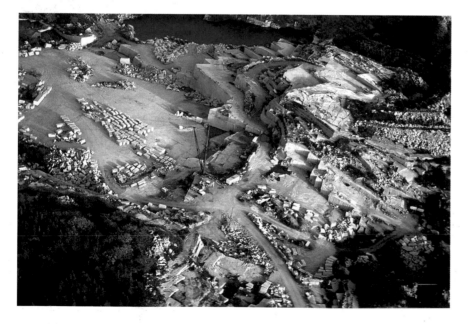

These four images are of one place in Maine. Prior to incorporation in 1897 under its present name, this town was known as Green's Landing and it is on an island reachable by car. During the Civil War this town endured the great sadness of losing a vast number of her sons, fathers, and husbands. For this reason, it was mentioned prominently in the Ken Burns public television documentary of that war. In more recent times it has received attention for a number of happier reasons. A few years back, it was featured in a book called *The Ten Most Beautiful Towns in America*.

A close look will reveal that the "industry" pictured here is a quarry. This was the source of premium New England granite that was carried by ship to such faraway places as New York and Boston.

If you have actually been to this town you might recognize the colorful sign, which is right on Main Street, as pictured above. It hangs two doors over from the red-roofed building. The image of the entire harbor and beyond reveals that this town sits amidst an "archipelago" of some considerable size. It is also the jumping-off point for visitors to Isle au Haut.

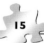

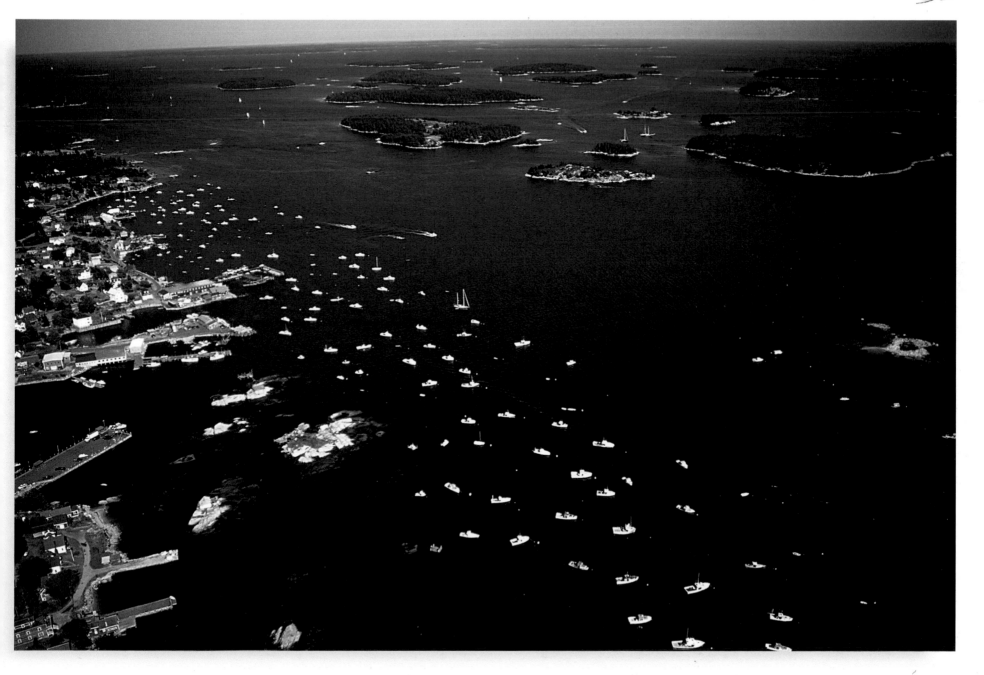

This beautiful stretch of the Maine coast—seen here at sunset on a winter day—is well known not only among lovers of ocean and wide open stretches of sand, but also by dog owners and their canine companions. After the summer-folk head home, and the weather turns chilly, this place becomes a veritable paradise for dogs. From October 31 through April 14, dogs of every description can be found here running off the leash, chasing Frisbees, each other, and the wind.

During the warmer months, this is a fine place for people to spend time walking, sunbathing, or just watching the waves lap on the gentle slope of beach.

The south end of the beach is bounded by the Morse River, and on the north end lies the mouth of the mighty Kennebec River. There is also a fortress that carries the same name as the beach.

*Okay, what is the name of this beach?*

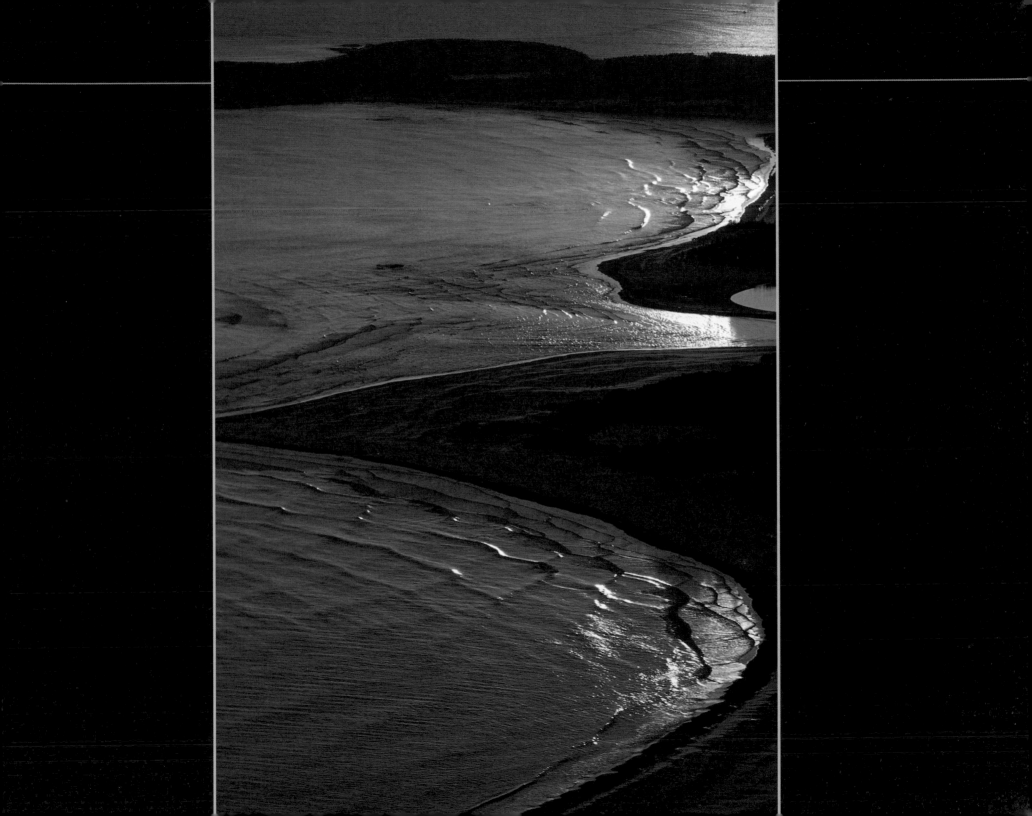

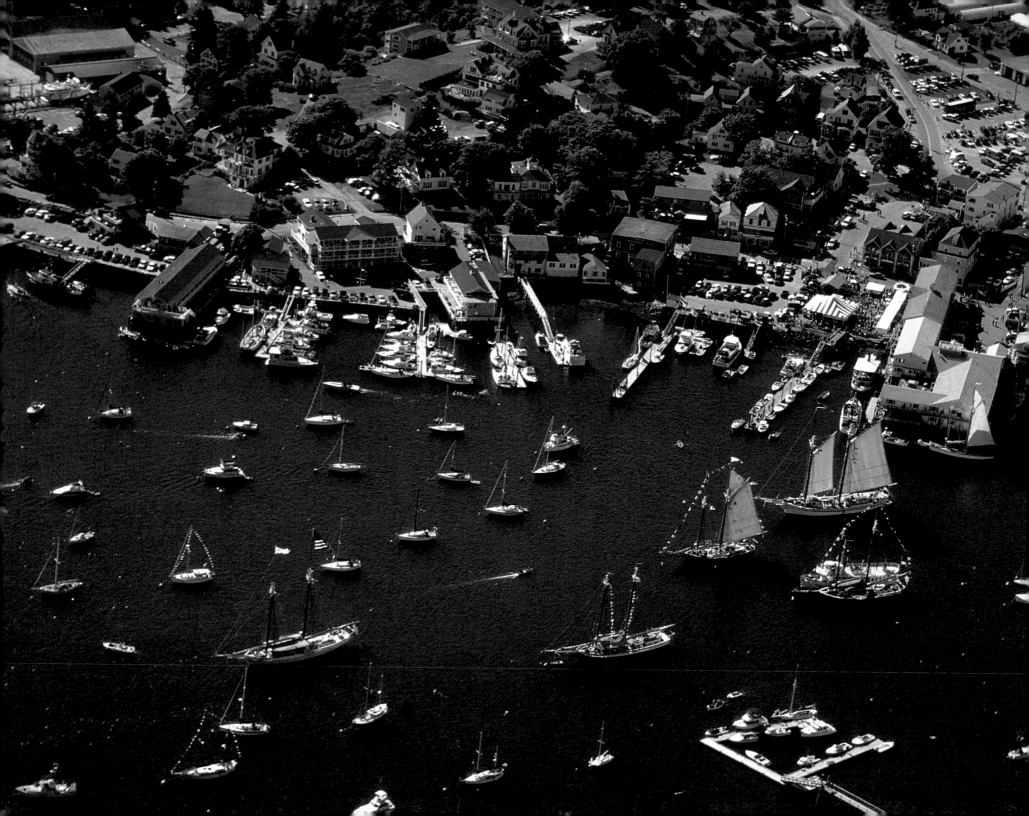

The phrase, "wooden ships, and iron men" describes the age of sail, but merely hints at the hardships of going to sea in a sailing ship. New England, more than any other region in America, has a tradition of going to sea in tall ships. The early colonists arrived here only after crossing the notoriously hungry North Atlantic in small but sturdy vessels, and many New Englanders turned to the sea for sustenance and livelihood. It has long been a way of life here in Maine. Henry Wadsworth Longfellow, a Portland resident, penned:

" I remember the black wharves and the slips,
And the sea-tides tossing free:
And Spanish sailors with bearded lips,
And the beauty and mystery of the ships,
And the magic of the sea."

Every summer, since 1963, there has been a gathering of windjammers to honor and to celebrate this rich part of our history. *Stephen Taber, Mercantile, Mistress, Victory Chimes,* and *Mary Day* are some of the ships that attend this event. These are painstakingly restored vessels that have found a second (third, fourth, or fifth) life carrying passengers on trips that range from a few hours to a week or more. During the event, the ships parade into and then out of the harbor, and it is truly a moving sight.

If you wanted to attend this gathering of windjammers, to which town would you go? And in what month?

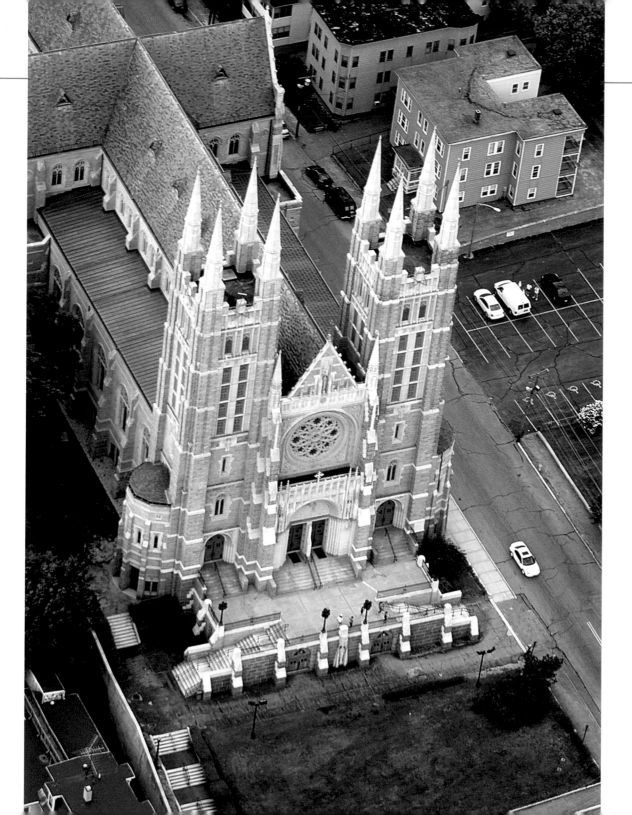

Here are images of two of Maine's most magnificent churches. A 'basilica' is a church that has been accorded certain ceremonial rights by the Pope. The name originally derived from Roman buildings that had been built for business purposes, but was adopted by builders of churches after the fall of Rome. There is only a handful of basilicas in the United States, and this elegant edifice belongs to that august group.

The church on the right—more properly called a 'chapel', due to its function—was built in the Romanesque style and is of stone, despite suggestions that building it of brick would save money. Ultimately, it came in at $46,790, a good indication of the time frame in which it was built. Today it costs that much to build a decent garage. This beautiful chapel is on the campus of one of Maine's colleges. Illustrious names from American history are associated with this college: Nathanial Hawthorne (who wrote

*The Scarlet Letter* and *The House of Seven Gables*), Joshua Lawrence Chamberlain, Harriet Beecher Stowe (who wrote *Uncle Tom's Cabin*), Oliver O. Howard (founder of Howard University), Robert E. Peary (the famous Arctic explorer), and not least, Henry Wadsworth Longfellow, who taught here from 1829 to 1835.

Here's a good hint: There is a schooner, famous since her launching in 1921 for exploring the Arctic, named after this college.

The basilica is named after not one but two saints, and it resides in a city that is often paired with another city on the opposite side of the Androscoggin River.

Okay, what is its name, and in what city does it stand? And, what is the name of the college where the Romanesque stone chapel presides?

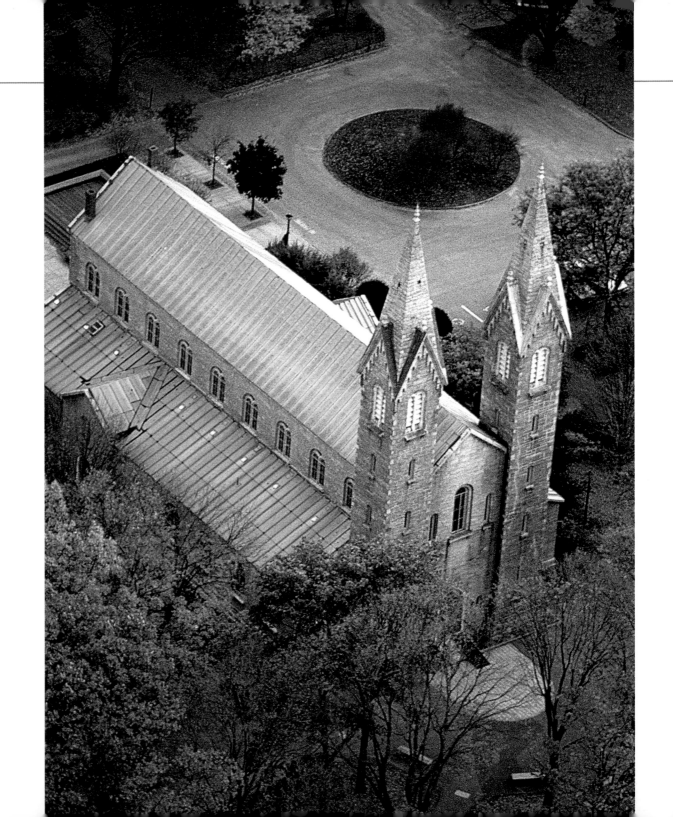

**O**f all the means that we humans have devised to elevate ourselves above the land, and to see from above, the balloon is the most enduring. People have been doing this since two French brothers, the Montgolfiers, devised the first one in 1783. And, despite the astonishing evolution of powered flight since that halcyon day at Kittyhawk in December 1903, people are still using a bag of stitched-together material to capture hot air and lift themselves into the sky.

The feeling of drifting along above fields, and farms, and over woods and lakes is amazingly peaceful. It is common to see wildlife going about their business and, except for the occasional brief blast of the burner—to keep the balloon's air warm and therefore buoyant—the flight is almost silent.

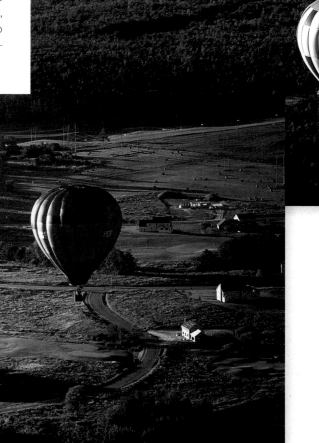

So, every summer in Maine there is a festival for these graceful marsh-mallows of the skies. Can you tell me where that takes place, and in what month?

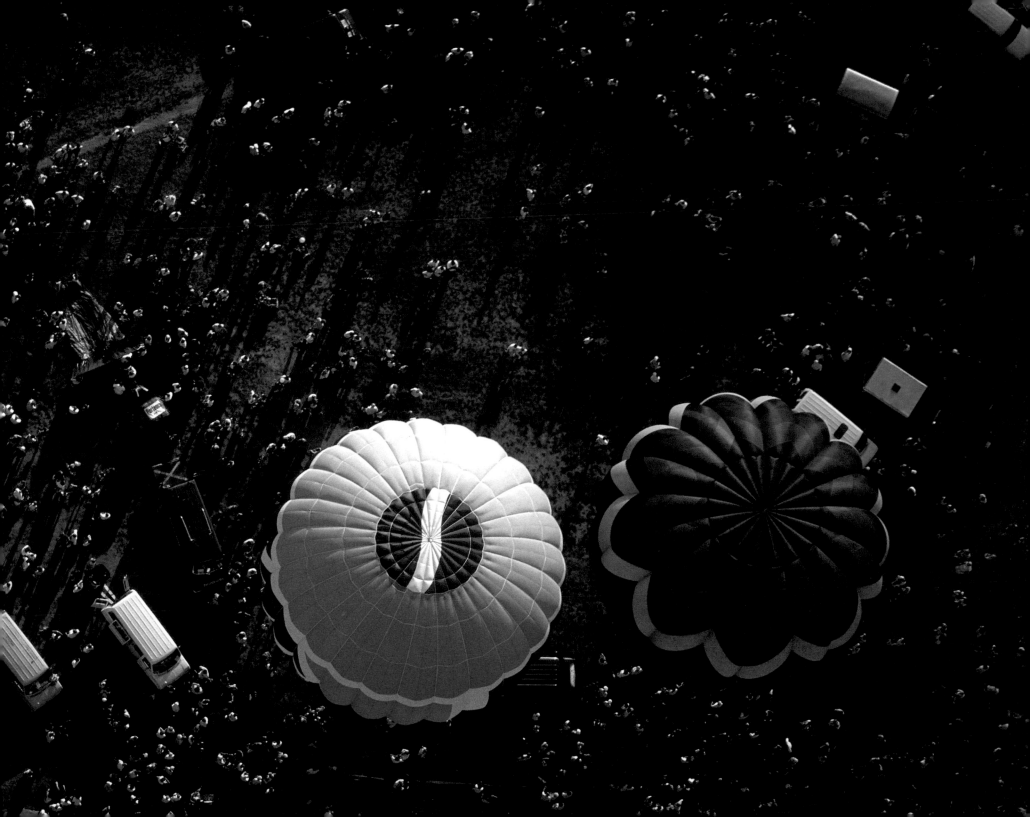

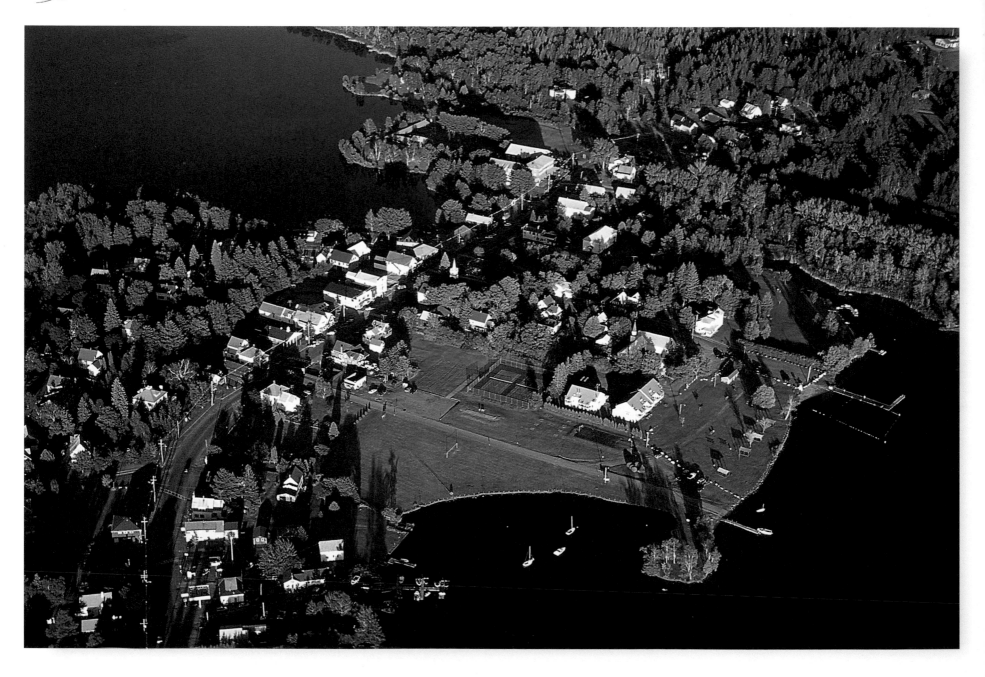

Maine is famous for its pristine and wild lakes, especially among those who love to fish. In addition to the lakes seen in this photograph, there is a whole cluster of lakes in a remote part of western Maine that is known collectively by the name of this town. This area is so popular as a destination for fly-fishing that L.L. Bean teaches an ongoing workshop there, helping those who find using a fly-rod and getting 30 feet of line whipping back and forth over their head a little challenging.

Just outside of town there is a museum that surely qualifies as one of the more unusual in New England. It is on the site of Dr. Wilhelm Reich's Institute of Orgonomy. Dr. Reich, a peer of Freud and Jung, actually lived out his days behind bars for marketing items that utilized something he called "orgone energy." Today we know that he was referring to the "prana" that is familiar to students of yoga, also called "chi" or "ki" by those who practice martial arts. It is simply the life force. At the museum you can see first-hand how a "cloud-buster" works. Or doesn't.

There is also a style of small boat that acquired the name of this town and it is eminently suitable for one to three people who want to fish on a lake, without paddling for miles to do so.

### HINT:
Okay, here is a good hint: You have to go through Mexico
to get to this town, if you are coming from the south.
Another? There is a sizeable and well-loved ski mountain outside of town,
called Saddleback.

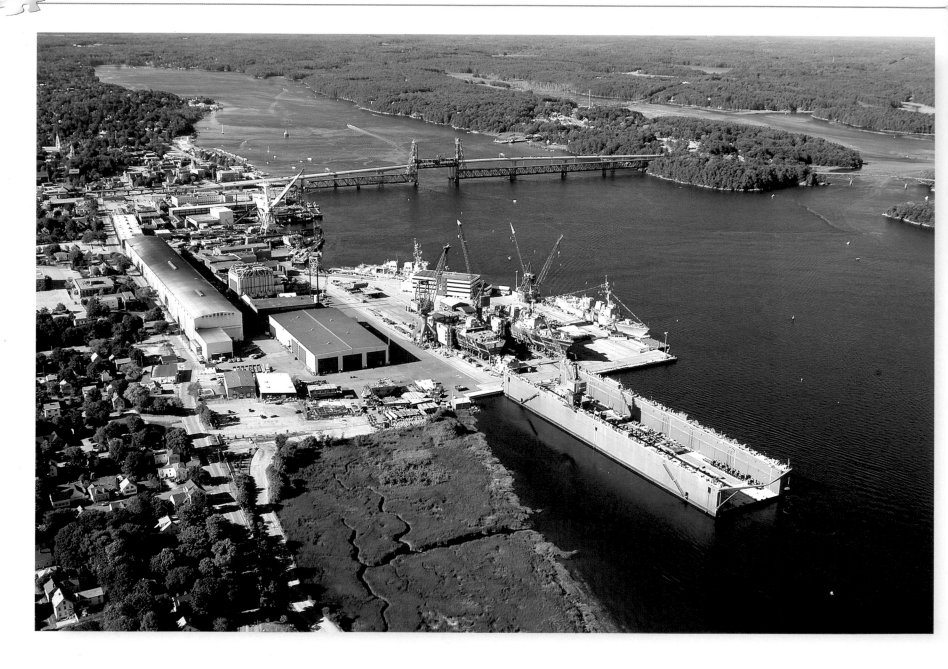

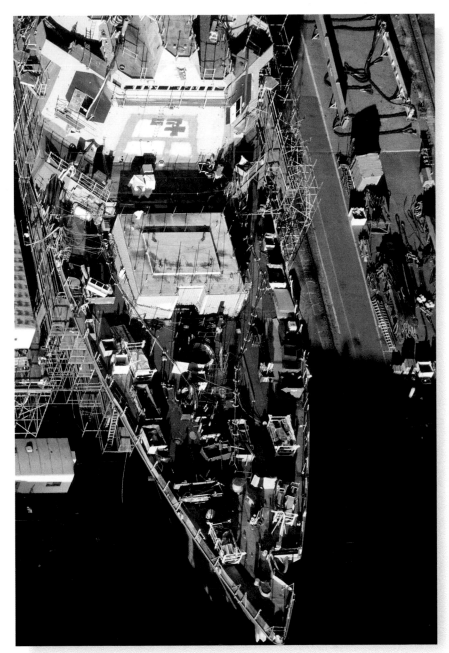

There's no disguising one of the nation's premier ship-builders. Bath Iron Works is known as a builder of highly sophisticated ships for the United States Navy. These amazingly complex and capable ships are built from scratch, one piece of steel at a time. That means hundreds of thousands of parts are individually formed and fabricated into sub-sections and systems, all of which must then be integrated into a completed ship without a single mistake. Inspectors test, measure, and pass or fail every task that must be accomplished. After years of toil, a new destroyer or cruiser finally sails down the Kennebec River to join the Navy's fleet as one of the most advanced ships ever built, with capabilities so sophisticated they are classified top secret.

Originally conceived in 1826, as an iron foundry, the first hull was built and delivered in 1890. During World War II, BIW built more destroyers for the U.S. Navy than all the shipyards in Japan could produce for the Imperial Japanese Navy.

Here is your mystery: what is the long blue object in the photo on the previous page, and how is it used in the shipbuilding process?

*Hint: The old method of launching a ship by having it slide down the "ways" is now obsolete.*

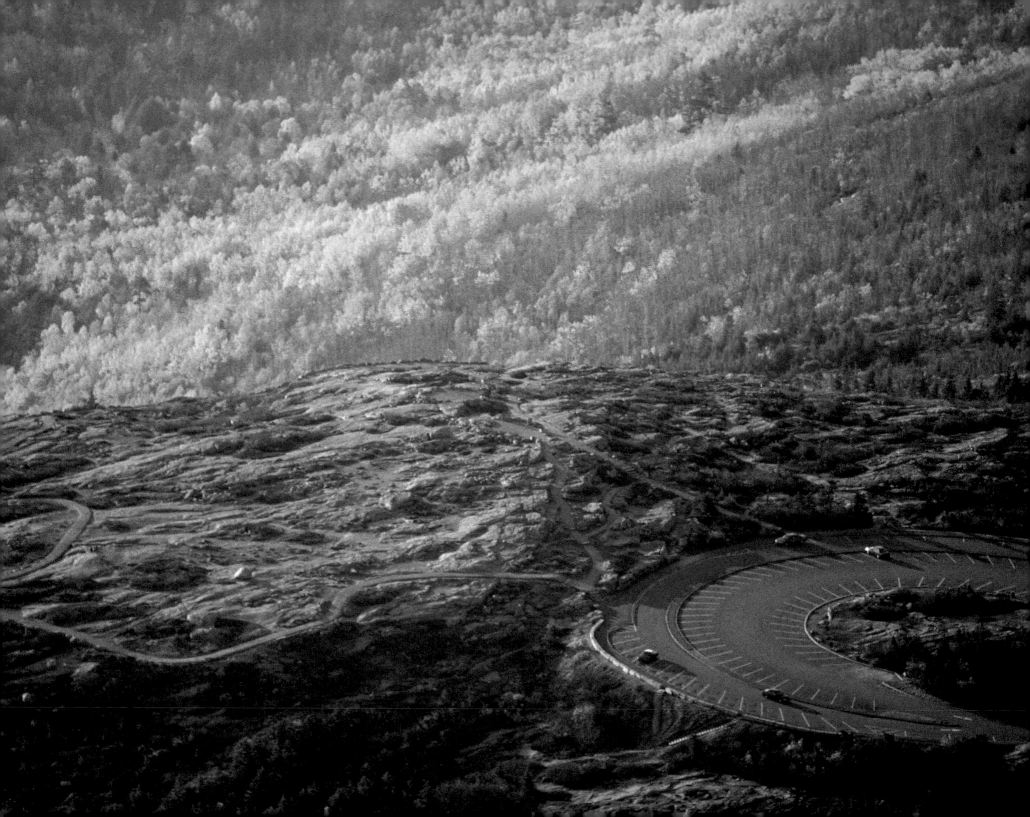

*What is the name of this mountain, and where is it located?*

The **circular parking lot** is a good clue. If you have ever been to this place, you may recognize it immediately. Combined with the trails that scamper out over the treeless rock beyond, and the neighboring mountainside in the background, it is a unique place. Here it is possible to watch peregrine falcons hunting; and, if you are an early riser, at certain times of the year this is the place to see the first sliver of sun as it breasts the horizon, before anybody else in the entire United States.

At 1,530 feet, it is the highest peak on the Atlantic coast of the U.S.

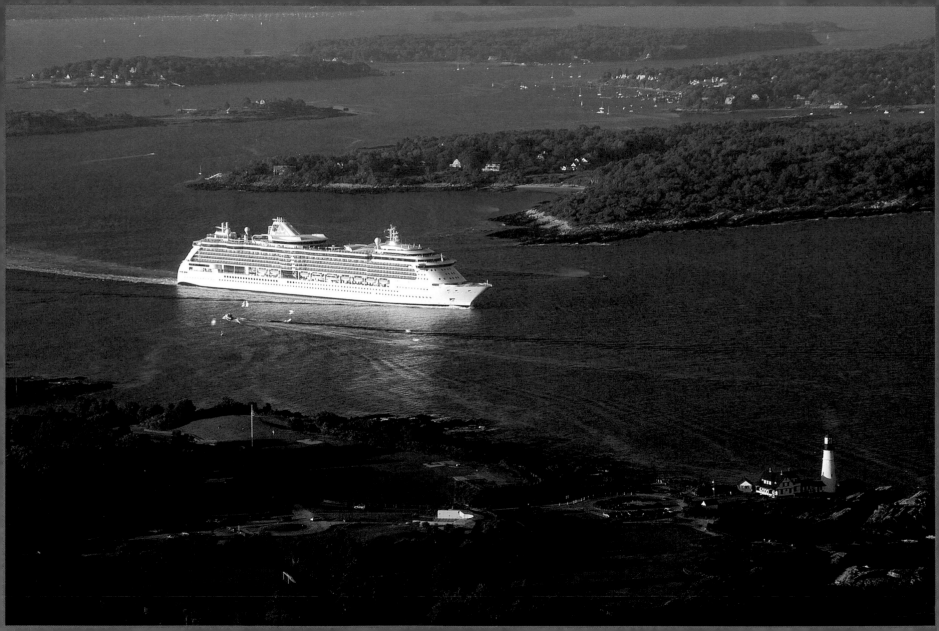

Both of these vessels carry passengers. One carries them very quickly, the other carries enough people to populate a sizeable town. Both visit Maine on a regular basis in the summer, and there are clearly visible clues in each image that will be helpful.

As you can see from the logo and the name emblazoned on her side, the futuristic, dark-painted ship is called *The Cat.* Her home port on the Maine end of her Canadian route has recently been changed. So, my question to you, dear reader, is: where is she now landing in Maine, and to what port does she sail in Canada? Can you explain what is unusual about this boat, relative to most ferries in this country? Also, do you know how fast she is and where she was built?

The graceful white cruise ship is on her way out to sea, having spent the day at a pier, allowing her passengers to go ashore and explore, shop, dine, and generally experience one of Maine's great attractions. What port is she leaving? The lighthouse in the lower right is a clue.

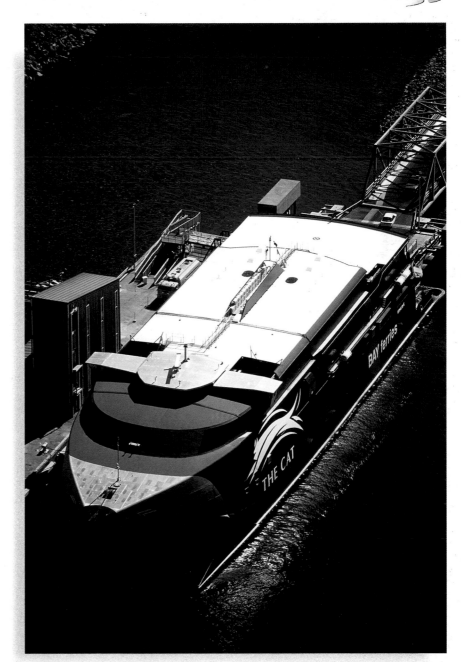

Have you ever come across lines of stone piles like these in the middle of a river and wondered what they were for? They had something to do with the log-drives of Maine's past that existed until 1963. Log-drives were a way of getting trees from the forests where they were harvested to mills that used them for either paper or wood products. The logs were dumped into the river by the thousands and floated down river in "rafts" that were often contained by booms of logs that had been chained together.

*So, what are these stone structures and how were they used?*

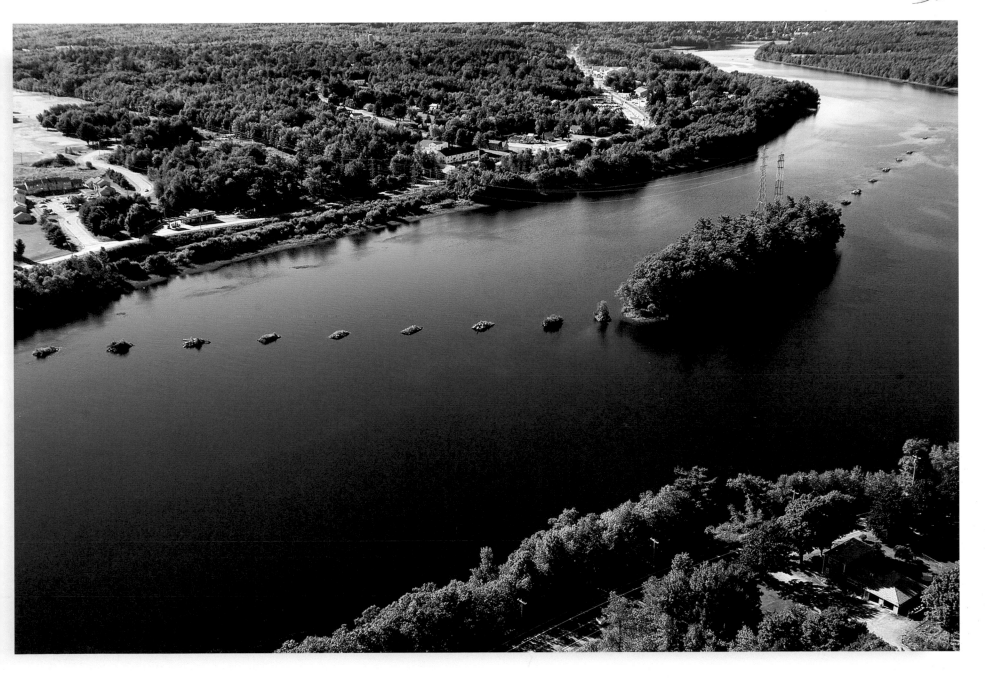

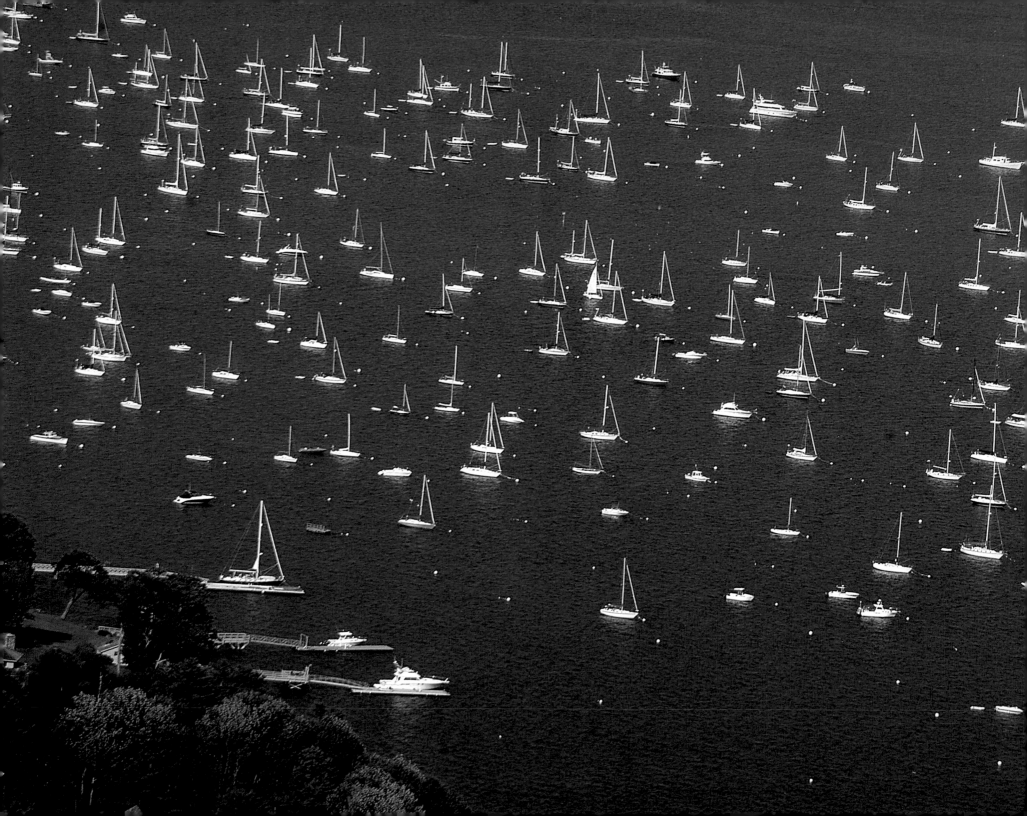

According to John Dalton, the harbormaster of this area, there are more than 1,300 boats moored in this anchorage. I will tell you that this is the anchorage at Falmouth Foreside, on Casco Bay. But the location is not the mystery here. Oh, no. The real mystery is how you find your boat when it is anchored in the midst of so many others.

Think about it. There you are, rowing around in your dinghy, muttering to yourself, "I thought it was just beyond that blue sloop with the green dodger." And, imagine how embarrassed you would be trying to explain to your guests for the day, that, "...it was right over here, somewhere." There are probably so many boats of every possible description, that you could be rowing until the boating season ends.

*So, there are two methods by which you can find your mooring. What are they?*

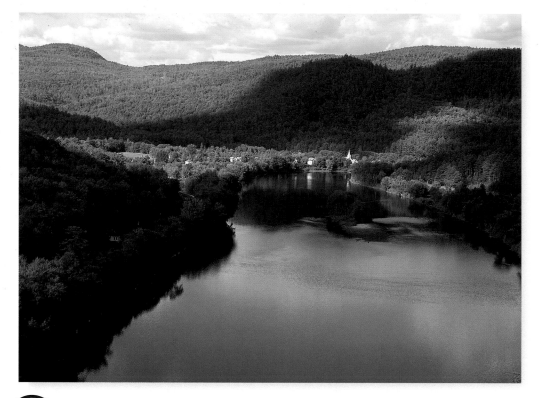

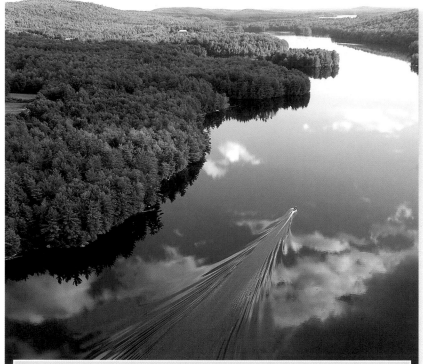

**O**ne of the real pleasures in making this book was spending time over our beautiful state of Maine. It is one thing to see it from ground level and quite another to look down on it from the perspective of a redtail hawk. On a perfect August afternoon, Chuck Feil picked me up at my local airport and we flew most of the length of one of Maine's great rivers. Here are three images of the river whose Abenaki name means "place where fish is cured." However, some think it was named as a slur to a despised royal governor of Massachusetts. But, if I tell you his name it will be a complete giveaway.

This river flows through three major locations where it is used for manufacturing, and was once listed as one of the top ten most polluted rivers in the United States. Although it is much cleaner than it was two decades ago, there is still a ways to go. The mills that have used it in the paper-manufacturing process are widely thought to be the primary culprits; but in actuality, pollution from development pressure and farming is now as much of a threat to this river.

Here are some good hints
that I hope don't make it too easy:

~ This river flows out of a series of lakes in the "up country" and travels 164 miles before it meets another of Maine's great rivers, at Merrymeeting Bay.
~ For ten years now, there has been an annual "canoe trek," sponsored by The _____ River Watershed Council.
~ Two "dead" rivers flow into it, but they aren't really dead.
~ For those who ski, the Sunday River also empties into it.

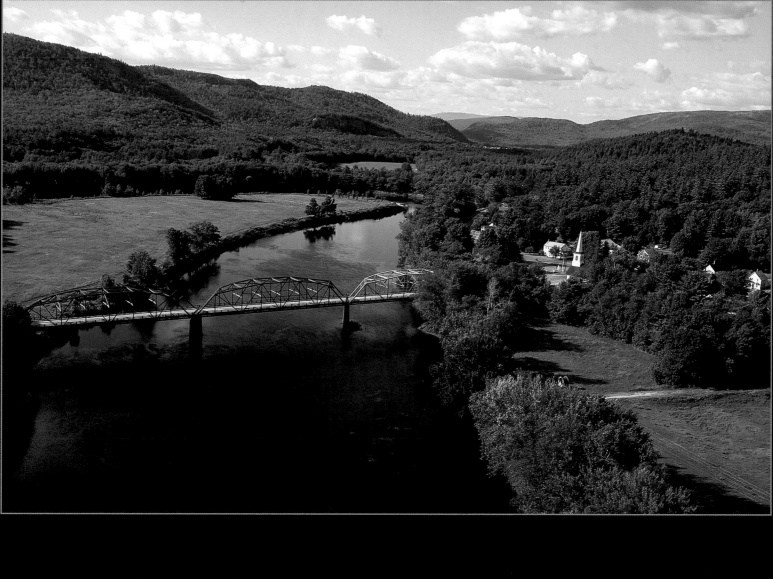

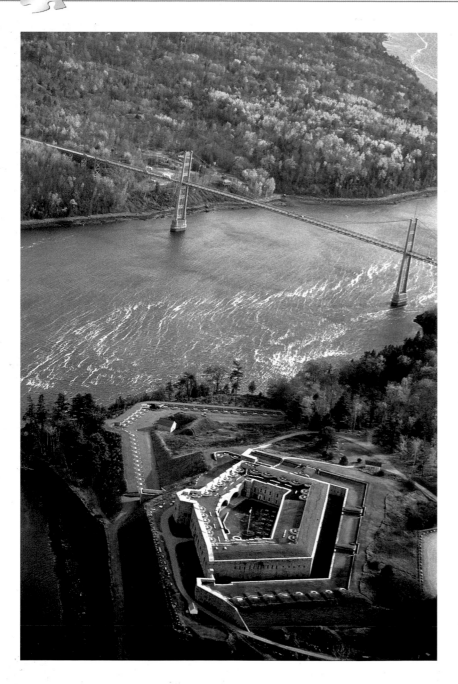

This fort is the single most visited national historic site in Maine. It was named after the first American Secretary of War, who was a Major General during the American Revolution and took on a mission to obtain heavy artillery for Washington's army at a time when they desperately needed it. Overcoming Fort Ticonderoga in a surprise attack was a daring undertaking that earned the namesake of this fortress a hero's accolades at a time when the faltering rebellion really needed heroes.

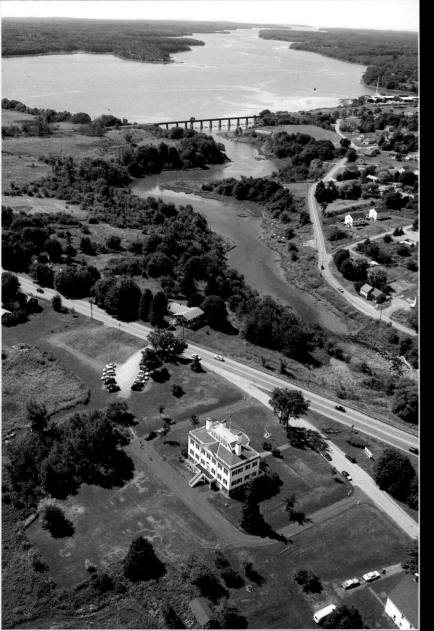

## Clues to the Name of This Man and Fort:

- The suspension bridge in the background *(which was replaced in 2006)* is a good clue to the fort's location. There aren't very many like it in Maine, and if you have traveled the coast on Route One, you have driven over this one.

- Montpelier, the beautiful mansion on a knoll, with a view down the St. George River, is located in Thomaston and was built by this same man. *(The home in the photo is a replica and not the site of the original home.)*

This city was originally going to be named "Londonderry," but a coin-toss was won by a fellow named John Miller, and so it was named after his hometown in Ireland. In the early days it was a prime fishing and lobstering port on Penobscot Bay, as well as a farming community. Today it is still a vital port, evidenced by the presence of at least one bright-red tugboat tied up on the waterfront.

There is also a railroad (well known to rail aficionados, at least) that serves this city. The other end of the line is at Moosehead Lake, which comprises half of the line's name.

Today this is a thriving center for the arts. I found twenty-seven artists listed in their registry, remarkable for a city of such modest size. There is also a large selection of restaurants, catering to diverse tastes. But, one of my favorite things about this place is just walking around the downtown area and looking at all the beautifully built 19th-century brick buildings. It is similar to the Old Port, in Portland, in that respect.

*What is the name of this fair city?*

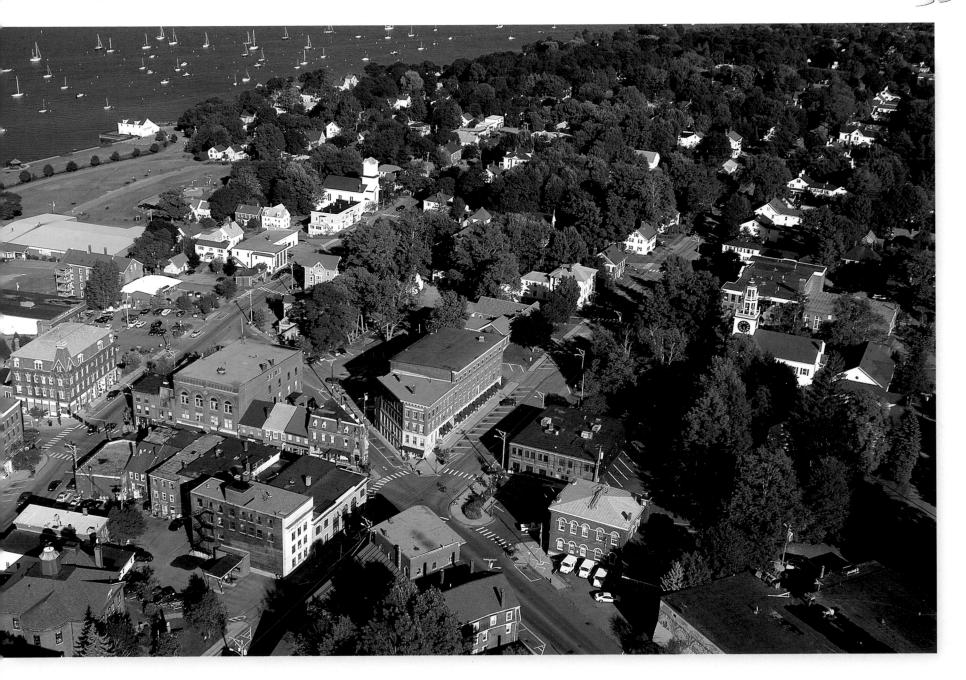

As stunningly beautiful as it is, the Maine coast is also a mariner's nightmare. With rocky shoals—many of them invisible at high tide—swift tidal currents, and fog banks that can creep in and enfold you, it is no surprise that these pristine waters are liberally salted with the wrecks of countless ships and boats. Over the centuries there has been an ongoing effort to make navigating Maine waters safer.

It took the grounding of a transatlantic steamer—the 400-foot *California*, in February 1900—to set in motion the necessary funding and planning to build this lighthouse. The ship was re-floated six weeks after she went aground, without loss of life, but it was obvious a terrible disaster had been narrowly avoided.

Joe Johansen, a keeper at this light in 1949 and '50, was interviewed by the Island Institute, of Rockland, and related that he'd been isolated there by stormy seas for 45 days running, and reduced to eating nothing but oatmeal. I suppose this might have figured in his decision to seek employment elsewhere, like Arizona.

This light has almost no visitors, but, due to its proximity to a lighthouse established in 1791, where visitors arrive by the busload, it is one of the most gazed-upon lights on the entire coast.

*What is the name of this lighthouse?*

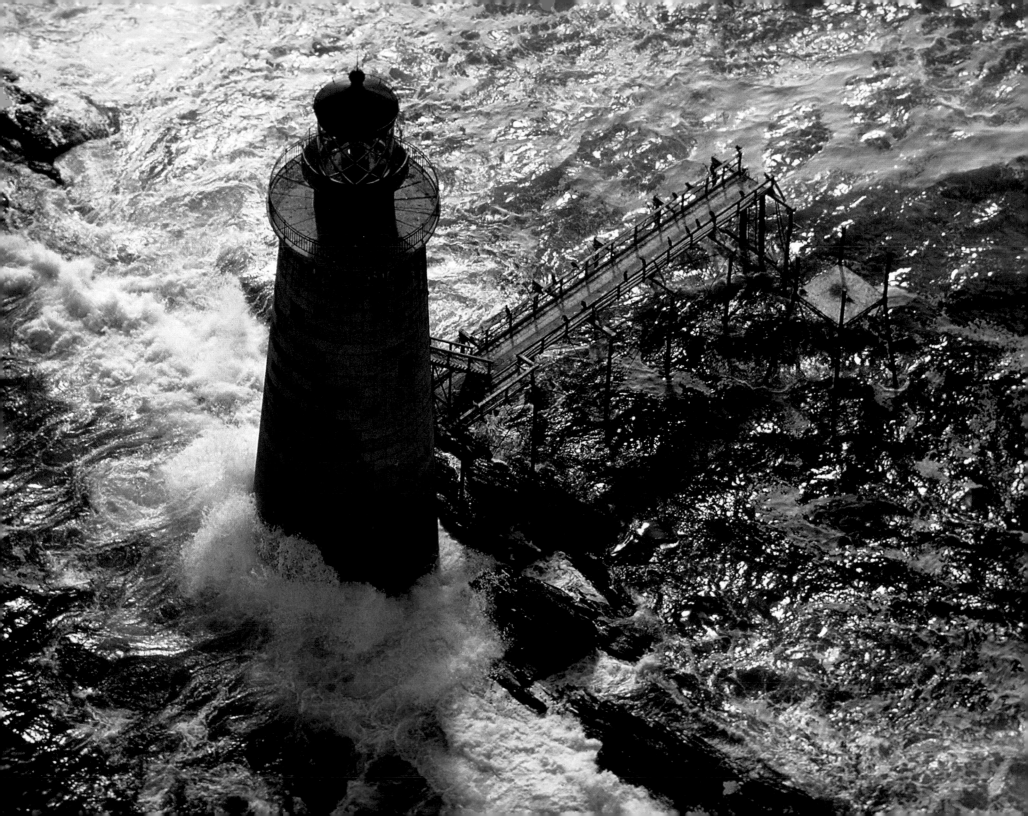

When most people think of Maine, about the last thing they picture is an area like this. But Maine is not only easy on the eyes, it is also a place of amazing diversity. About 11,000 years ago, however, Maine wasn't such a great place to live or visit. It was under a sheet of ice approximately one and a half miles thick. This ice sheet was so heavy that it actually pushed down on the land with enough force to lower it several feet. There are rocks on the Eastern Promenade in Portland that clearly show the striations created when the ice dragged stones across it.

Having this ice advance and retreat across the landscape brought many changes, and one of them was the deposition of vast quantities of sand in particular places. The sand was later covered with loam, topsoil derived from decayed plant and mineral materials. Unfortunate farming practices in the days before erosion control was well understood caused the loam over the area in this photograph to be stripped away. This left a large area of sand surrounded by forest.

*What is the name of this area and where is it located?*

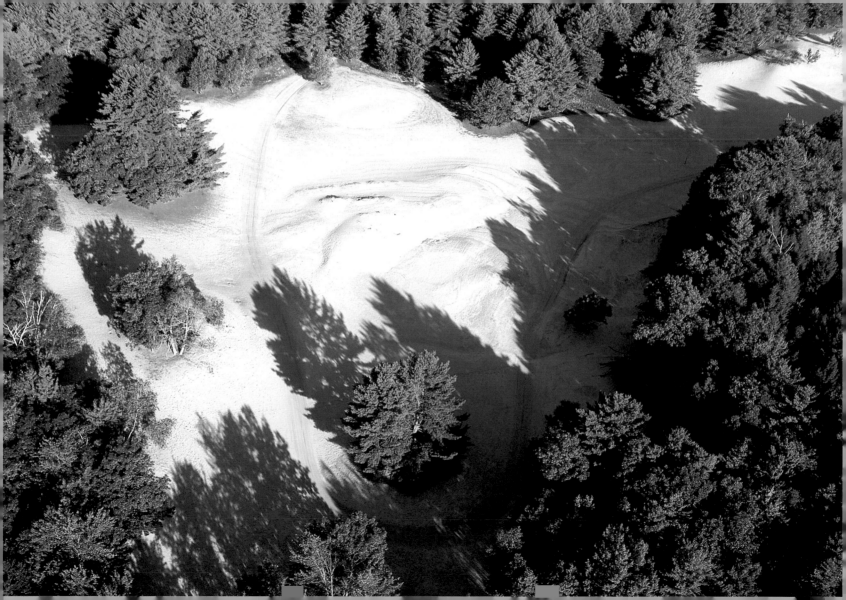

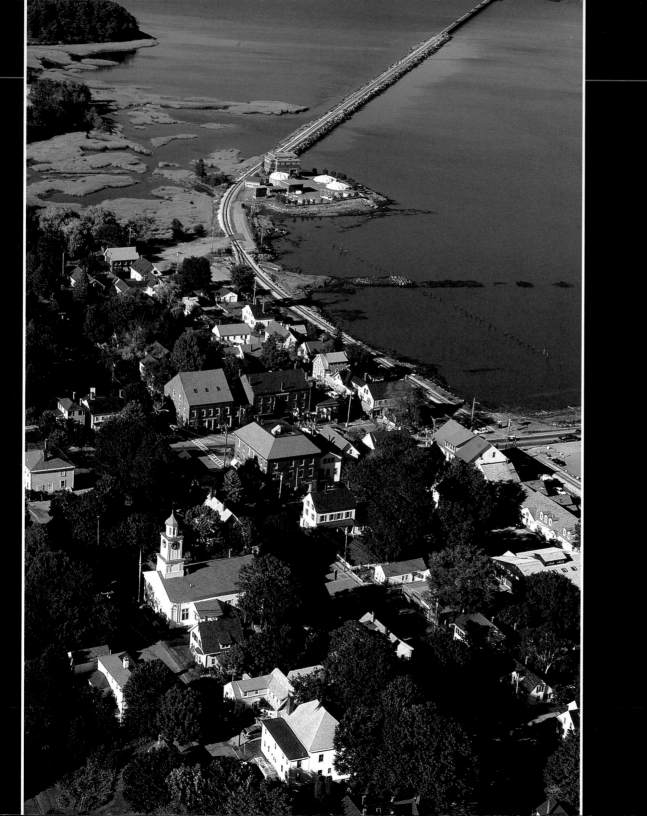
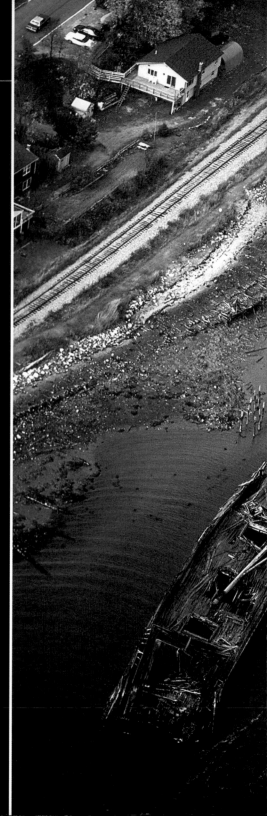

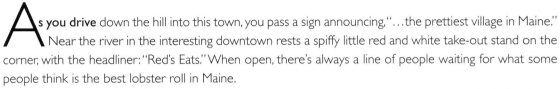

As you drive down the hill into this town, you pass a sign announcing, "…the prettiest village in Maine." Near the river in the interesting downtown rests a spiffy little red and white take-out stand on the corner, with the headliner: "Red's Eats." When open, there's always a line of people waiting for what some people think is the best lobster roll in Maine.

Diagonally across the street from Red's is the spot where the *Hesper* and the *Luther Little* (right photograph) used to rest. Originally built to carry coal from Boston, the schooners couldn't compete in the age of steam and were left derelict, slowly falling in on themselves, broken masts jutting skyward. The wrecks were finally demolished in the late 1990s.

So, what town has "Maine's Prettiest Village" on its welcome sign? And do you know on what river the town sits?

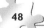

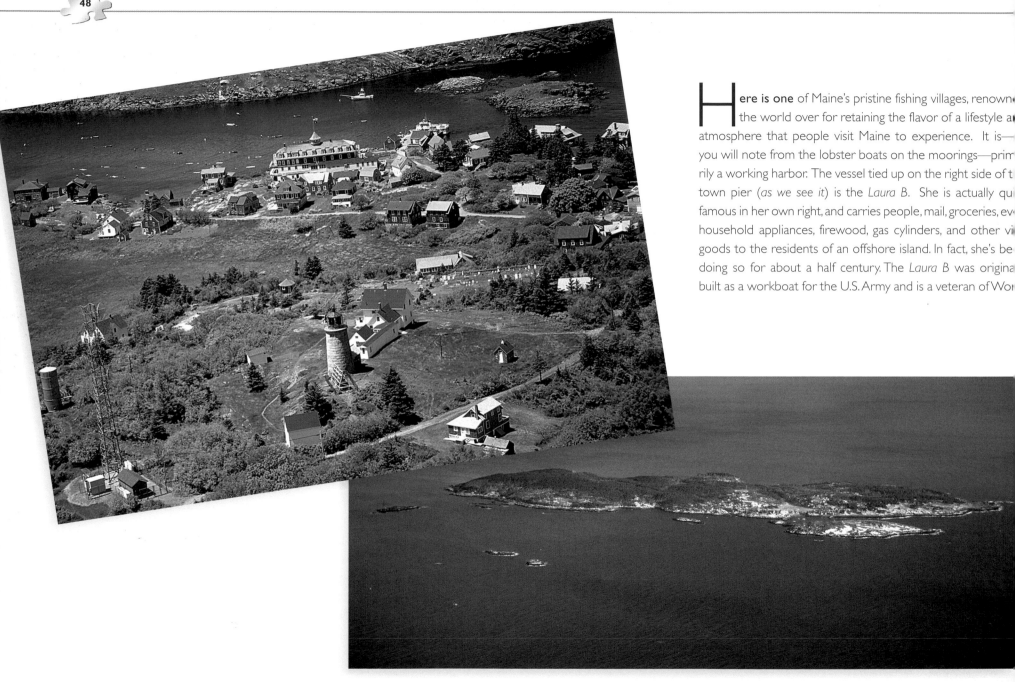

**H**ere **is one** of Maine's pristine fishing villages, renown the world over for retaining the flavor of a lifestyle a atmosphere that people visit Maine to experience. It is— you will note from the lobster boats on the moorings—prim rily a working harbor. The vessel tied up on the right side of t town pier (*as we see it*) is the *Laura B*. She is actually qu famous in her own right, and carries people, mail, groceries, ev household appliances, firewood, gas cylinders, and other vi goods to the residents of an offshore island. In fact, she's be doing so for about a half century. The *Laura B* was origina built as a workboat for the U.S. Army and is a veteran of Wo

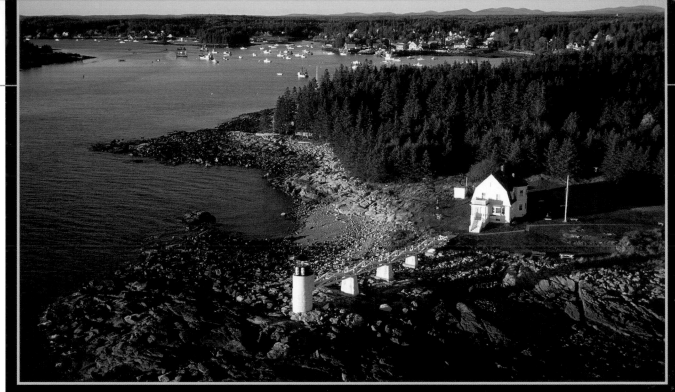

Var II in the South Pacific. She even came under fire and was
riginally equipped with two .50-caliber machine guns on deck
mounts.

In 1995 she was joined by the 65-foot *Elizabeth Ann*, which
lso plies the same route. There is a lighthouse only a short
istance away, out of the right side of the photograph. It has a
ong elevated walkway leading to it from the front yard of the
eeper's house.

*Vhat Maine fishing town is this? What island does the* Laura B.
*ervice? And, what is the name of the lighthouse?*

HINTS:

~ You can see the island from Pemaquid Point;
  it sits about nine miles out.

~ The island is where the wreck of the
  D.T. Sheridan sits, on Lobster Point.

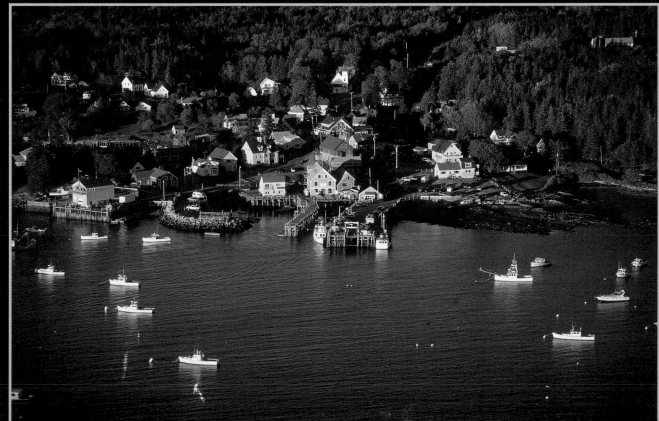

Talk about mysteries, even the U.S. Geological Survey apparently doesn't know the answer to this question: What state has the longest coastline in the lower 48? In a "science challenge" on its website, the Survey states firmly that Michigan is the winner, with 3,288 miles of coastline. The conventional wisdom here in Maine has traditionally mentioned a number close to this.

But, wait just a minute. A book on the Maine coast from Down East, *Islands in Time*, puts the magic number at 7,039, along with noting that Maine has 4,600+ islands. The Maine State Planning Board—about as official an organization as one might wish for—breaks it down by county, and firmly states that the figure is 5,299.9. Which makes me wonder how anybody can be that precise about something so widely debated. I mean, did they measure it at high or low tide, and if high, was it a "neap-tide," or perhaps a "spring tide"?

Okay, then how long is the Maine coast? And, remember, that does include the shorelines of all those islands as well as the mainland. You already know that Michigan is shorter, at more than three thousand miles.

*So, what is the* actual *length of Maine's coastline?*

*And a bonus question: What is a neap tide and what is a spring tide?*

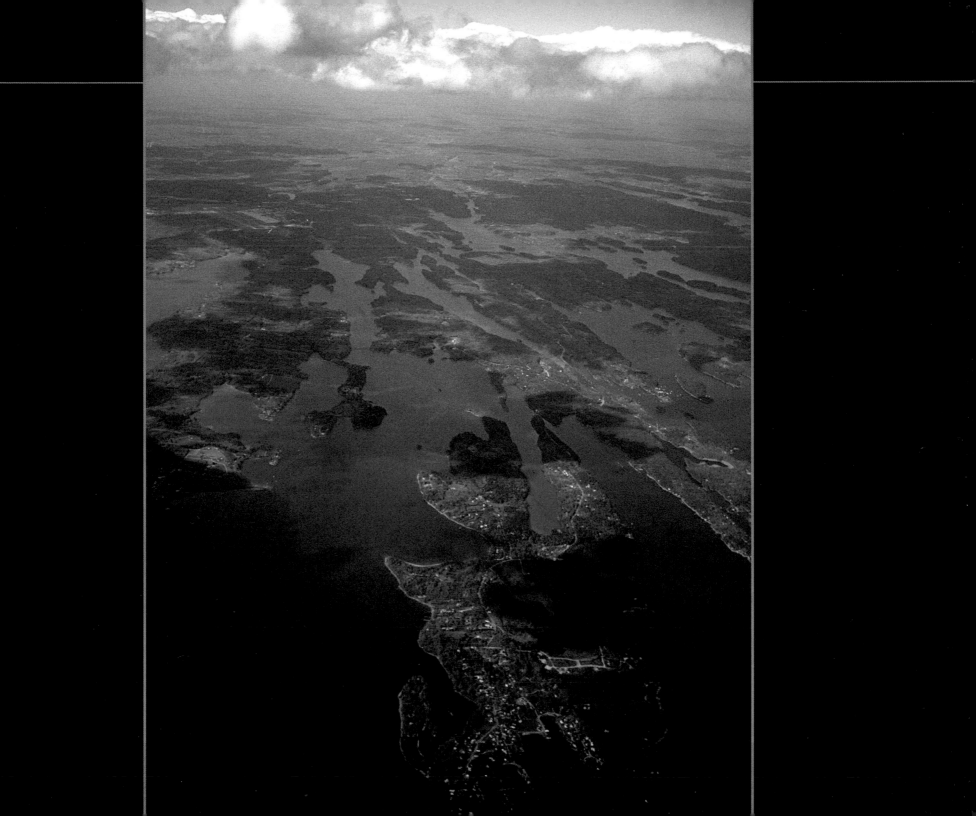

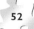

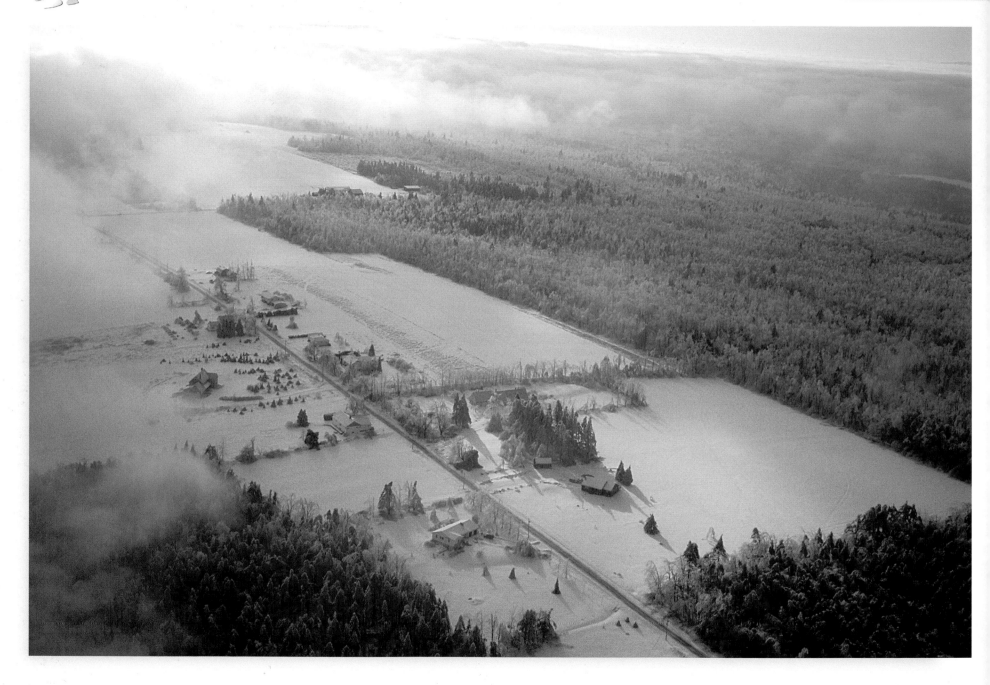

If you look closely at the image of the forest, it is apparent that nearly all the white birches are bent double. Only one situation could cause this to happen—an ice storm like no other.

So, when did this infamous ice storm occur, and what was its effect on our state? Can you guess the most distant state to send repair crews, and what they did here? If you are a Maine history buff, you might recall that this was a disaster of major proportions, with very serious results.

What were some of those results? After the storm, a neighbor of mine in western Maine showed me a shriveled tan beech leaf that she'd put in her freezer. She announced proudly that it weighed two-and-a-half pounds! Imagine how many pounds of ice must have formed on an entire tree.

The visual effect was absolutely amazing. Even areas of scrubby puckerbush were transformed into a fairyland of dazzling glass menageries. There was also a darker side to the doubled-over birches. Many, if not most, of them never straightened up again. Some just snapped off at full bend.

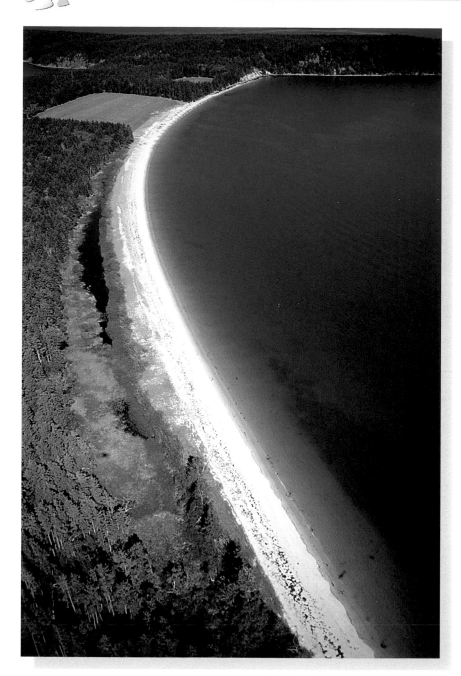

At first glance, the white sand and the clear, blue-green water might lead you to believe this gorgeous beach is somewhere in the Caribbean. Then you would come to your senses, put away the catalog of all-inclusive getaways, and realize that if you want to swim here you had better either belong to your local polar bear club, or bring a lightweight wetsuit. Those are fir trees, and that water is frigid. One summer visitor mentioned 55-degree water temps.

Ah, but where is this beautiful place? It certainly looks like an inviting place to have a summer picnic or to take a nice stroll on a day like the one pictured here.

Here are some facts
that will help you zoom in on this location:

- It is located on an island that is part of an archipelago
- The archipelago is bounded on the southwestern side by Chandler Bay and on the northwestern side by Englishman Bay.
- The main island is distinctly "H" shaped.

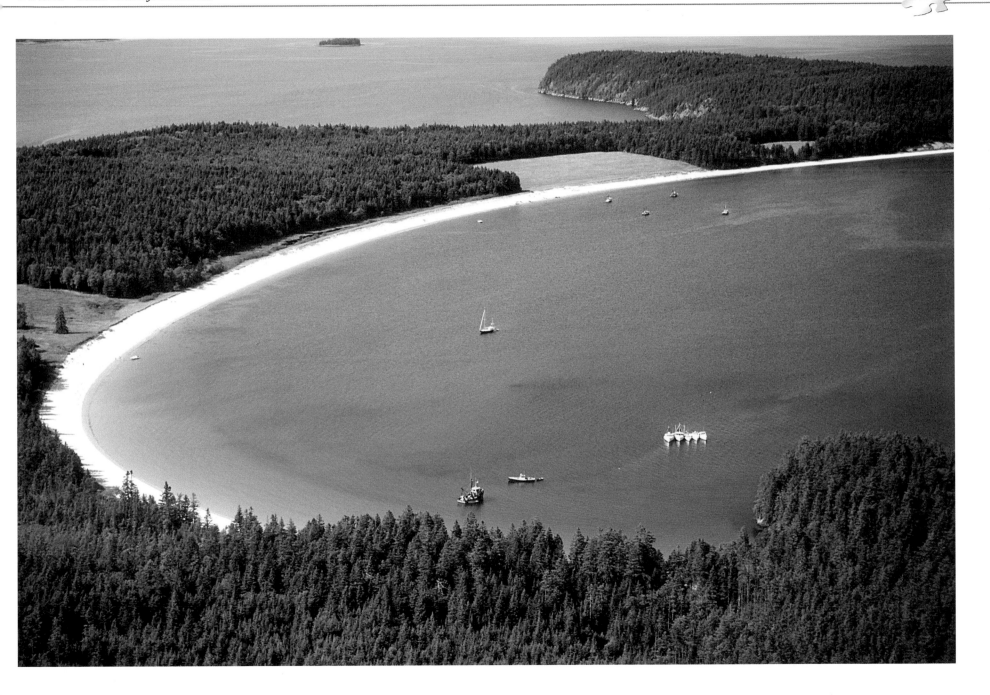

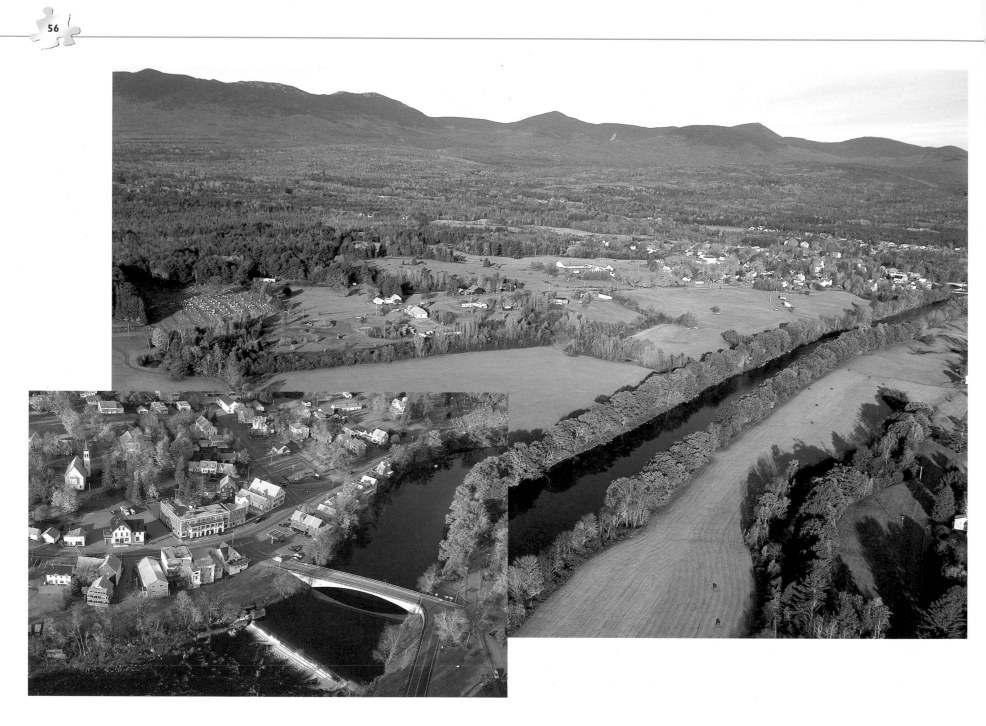

ocal historians believe that Benedict Arnold's men passed this way in the fall of 1775, on their way to Quebec, a journey that met with failure.

In 1937 a section of the Appalachian Trail was completed through this area, and in 1948 the "Bigelow Boys" cut a ski trail on the north side of Bigelow Mountain. Shortly thereafter a dam was built on the Dead River, which cut off road access to Bigelow. The Bigelow Boys then moved to the next mountain to the south, and the rest, as they love to say, is history. A well-known ski resort is now located there, and a school in this area has been instrumental in training such world-class athletes as Bodie Miller, Kirsten Clark, Boyd Easley, Emily Cook, and Seth Wescott. This is the kind of school I wish my parents had sent me to, but lest you think it is just a ski school, the list of colleges that its graduates attend is bespeckled with ivy.

The river running through the photograph has the same name as the valley, and the town in the middle distance has a rather "royal" sounding name. There seems to be no clear agreement as to how the name of this town and the surrounding area translates from the original Abenaki. It is variously rendered as: "Small Moose Place," "Sturgeon Place," or "Sharp Rock Place."

What is the name of this valley? What is the mountain? Name the town shown in the bottom photo on previous page.

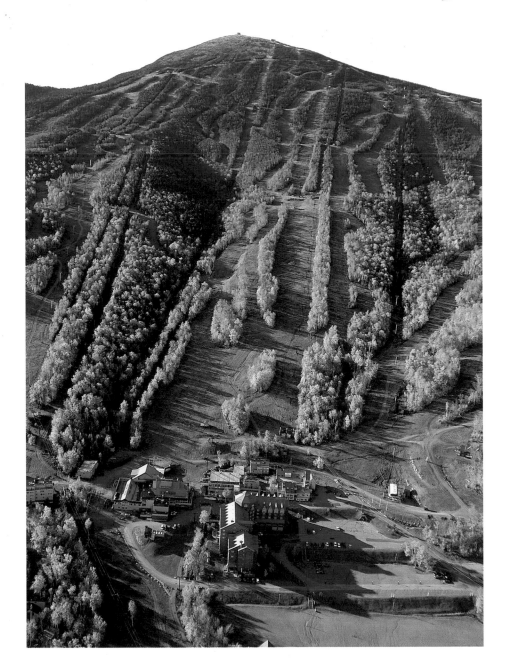

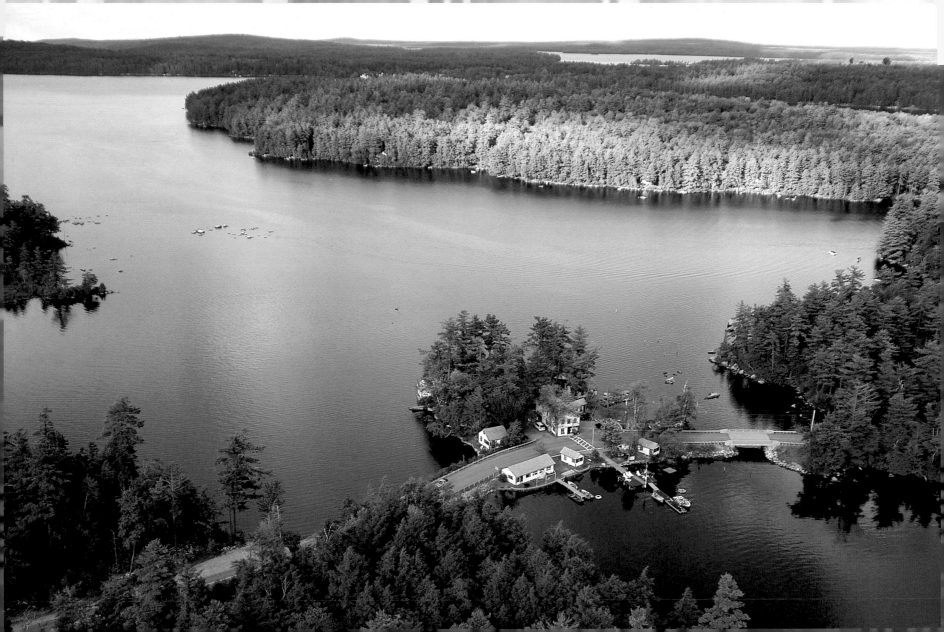

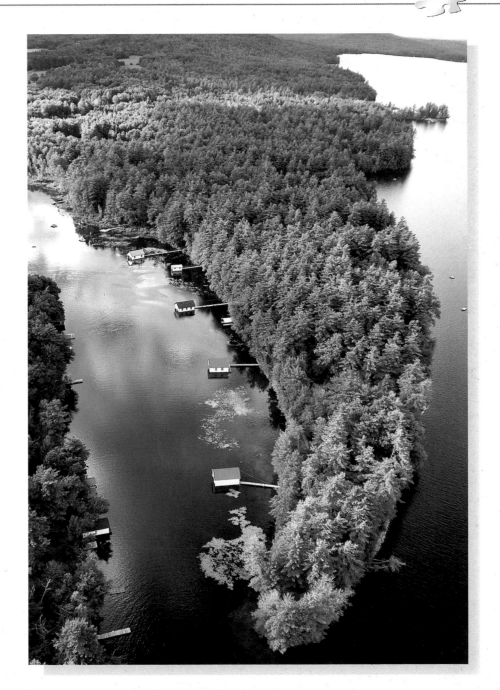

**M**aine is a state of many wonders that also has very distinctive regions. These images record one of these regions—a mecca for campers, fishermen, and vacationers for many generations now. Small- and large-mouth bass, northern pike, pickerel, and brown trout are sought after by "sports"—as Maine guides have long referred to their clients—who come from all over the world. What area is this? And, what is the name of the camp pictured here, with a causeway on either side of it?

HINTS:
- The camp is a long-time icon in this area and was named for its founder, though some might imagine that it was given its name because it is surrounded almost entirely by a moat—of sorts.
- The camp is on Long Pond, which is not all that distant from another *great pond*. Camps that have boathouses on stilts, with footbridges, are particularly unique to this region of Maine.
- The name of this region, and the principle town in it, is also that of a city in the former Yugoslavia.

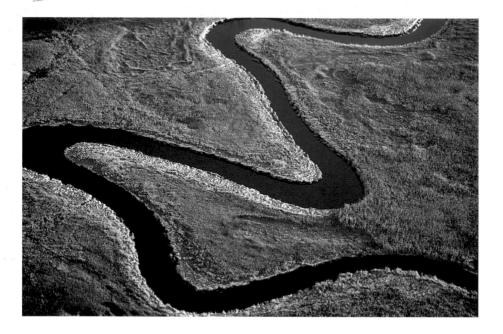

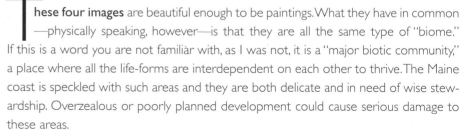

hese four images are beautiful enough to be paintings. What they have in common —physically speaking, however—is that they are all the same type of "biome." If this is a word you are not familiar with, as I was not, it is a "major biotic community," a place where all the life-forms are interdependent on each other to thrive. The Maine coast is speckled with such areas and they are both delicate and in need of wise stewardship. Overzealous or poorly planned development could cause serious damage to these areas.

This particular kind of living community is combined in a way that produces stunning abundance and diversity. It is an "ecosystem" and this particular type is the richest of all of them. What is surprising about the biomes pictured here is that one acre of such a place is capable of producing more food than the most productive farmland that exists anywhere.

Such areas simply teem with life, from birds, plants, and animals, to bacteria, mollusks, and crustaceans. More than 250 species of wildlife can be found in such a place.

*So, what is the name of this critically important and wonderfully diverse habitat?*

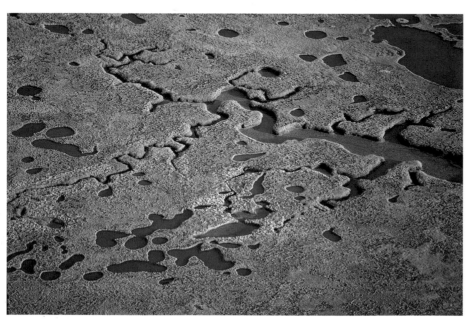

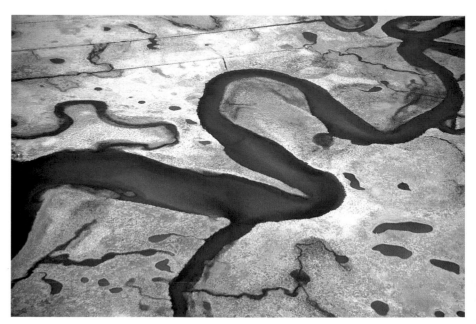

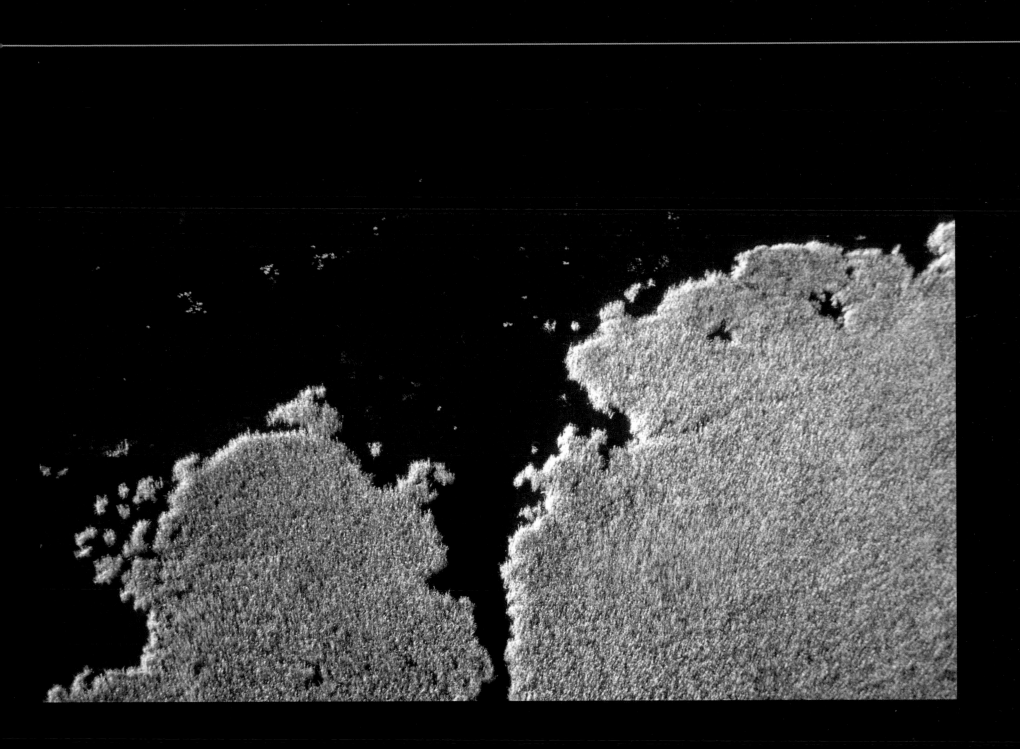

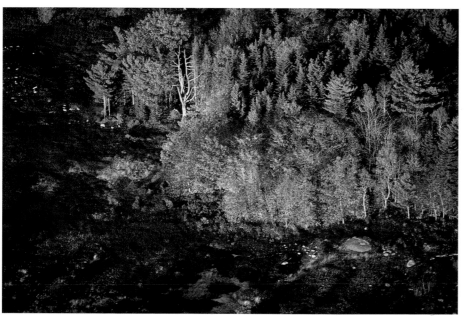

These three different areas are all used for the same purpose: growing blueberries. In fact, each year Maine produces about 90% of a particular type of blueberry harvested in the U.S., which requires nearly 60,000 acres of these lands. But, here's the mystery: Maine is the world-wide *leader* in the production of a particular type of blueberry.

Growing blueberries is a long-standing tradition in Maine. The original Mainers, Native Americans, valued them as food, but also as dyes, paints, and for healing. And, as research continues on this remarkable little berry, it is becoming apparent that they are not only the leading antioxidant-rich fruit—outstripping even broccoli and strawberries—but also that they contain a substance that can improve your vision: anthocyanin. Who knew? Well, actually, the University of Maine did, and has an entire commission, with its own website devoted to blueberries. This shouldn't surprise anybody, however, because the annual crop of Maine berries is valued at around $75 million dollars. The largest crop—expected to be surpassed this year ('06)—was 111 *million* pounds.

Here is your challenge: what distinguishes most of Maine's blueberry crop from the bulk of blueberries? And, what are these places—as you see in the accompanying photographs—called….and why?

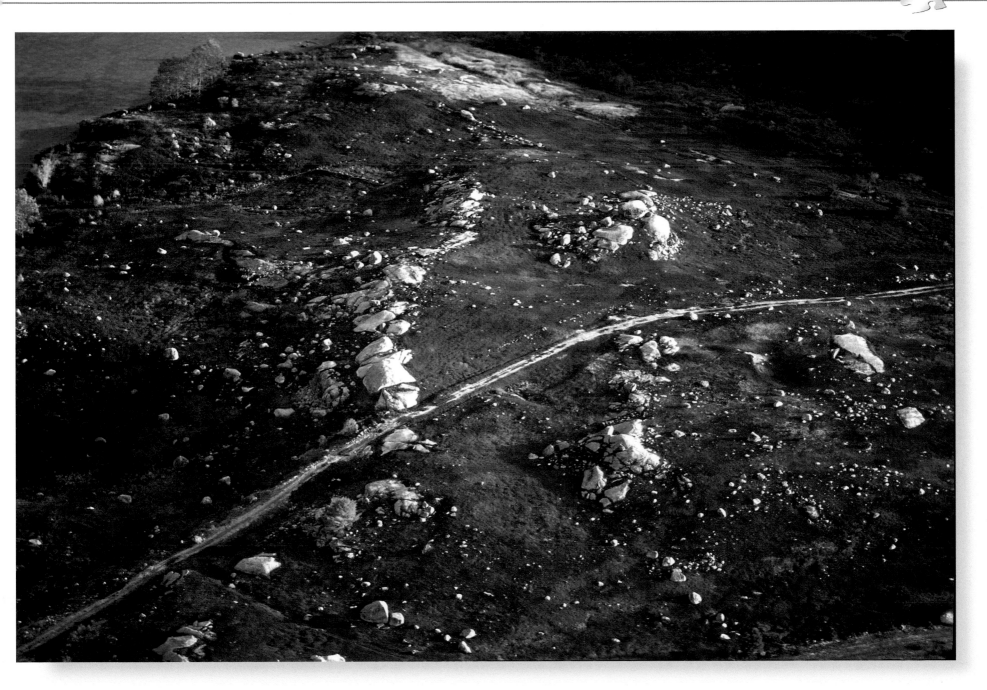

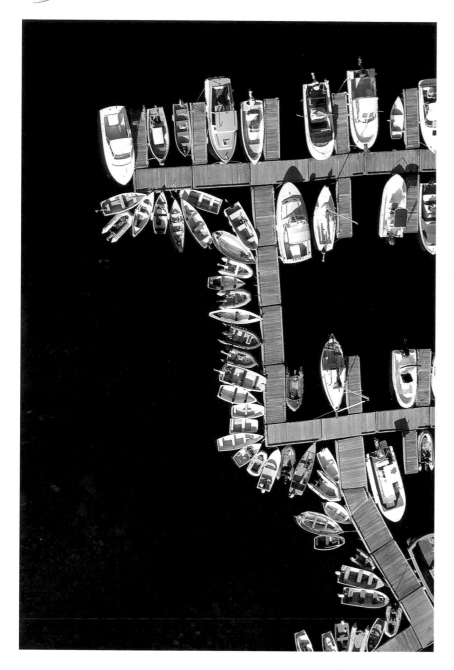

This town on Penobscot Bay has some very skilled craftspeople who build traditional wood boats. The collection of dinghies at the dock contains some beautiful examples of the boat builders art. This is also a good place to climb on board and spend a day sailing on one of Main famed "windjammers." As you sail out of the snug harbor, you will pass Curtis Island Light starboard.

It was in this town where the movie *Peyton Place* was filmed. It was also the home of Ed St. Vincent Millay, the famous writer and poet.

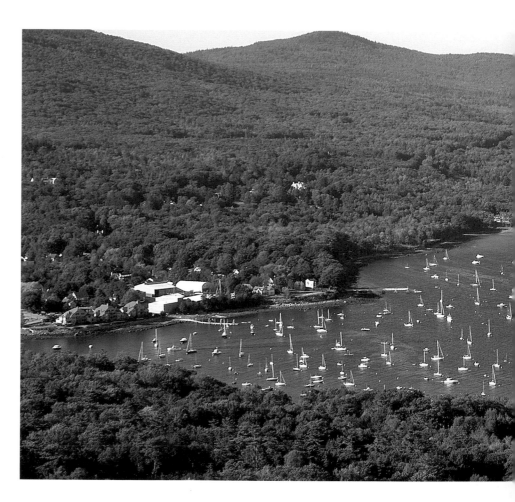

The downtown shopping district is chockablock with art galleries, fine restaurants, and inter-ting shops. Directly overlooking the town is a landmark seen for miles at sea. And not far out town there is even Maine's only coastal ski area, known as the "Snow Bowl."

*Okay, that's a pile of clues. Now, what town is this?*

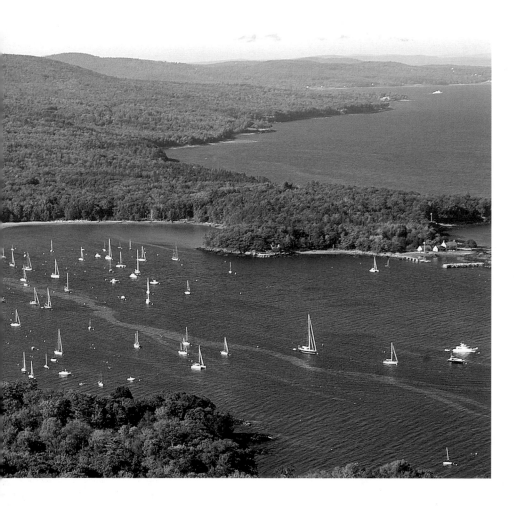

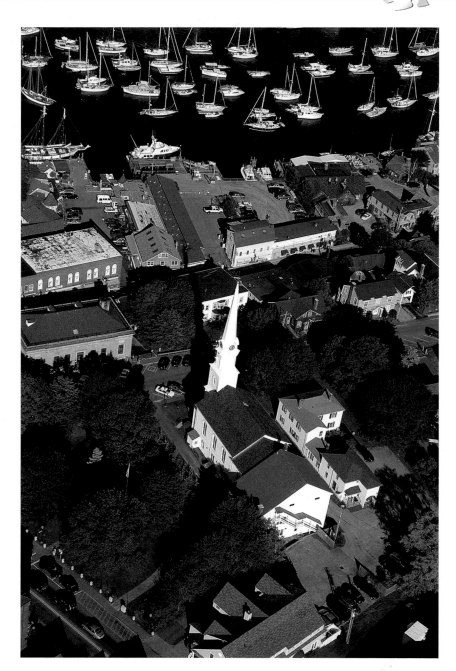

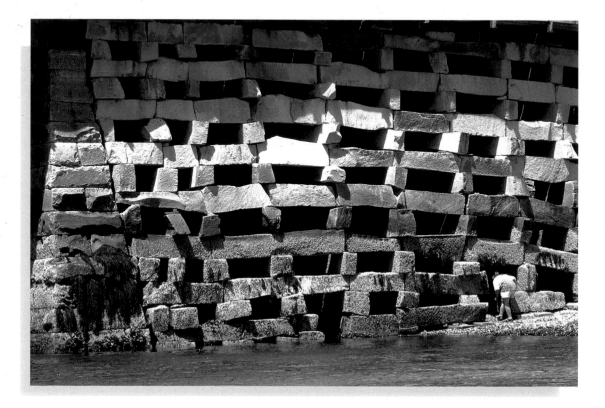

These are two views of a particular bridge and causeway. The bridge was opened to traffic in 1928 and is believed to be one of only two of this type in existence. In the close view one can see that it is not made of blocks of cast concrete, as one might expect, but of sizeable chunks of quarried granite. These were split into the sizes you see and carried to the site from Pownal and Yarmouth.

There is no mortar holding the blocks of granite together; it is all the work of gravity and the skillful judgment of the men who built it. Each block—far too large to be lifted into place by hand—had to be hoisted and carefully positioned so that it would be locked in place by the weight of the entire structure when finished. They did a remarkable job, because it is still in excellent condition 77 years later.

One of the reasons this bridge is considered unique is that its method of construction doesn't block the tidal currents through Will's Gut, but allows them to flow through the causeway. This is an important feature if you consider that there would be a powerful, even dangerous, tidal flow through the bridge opening without it.

*Okay, where is this bridge and what is the term for this method of construction?*

**Hint:**
*This bridge joins two islands that are often mentioned in the same phrase.*

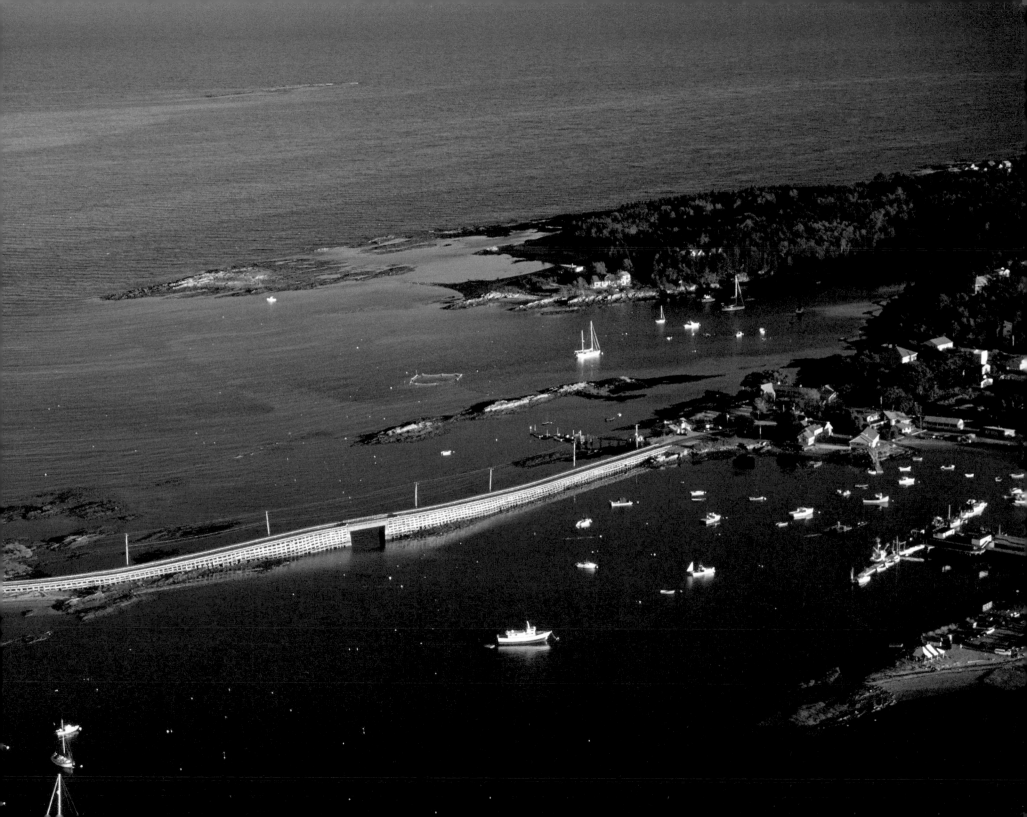

**Y**ou are looking down on a place that people by the thousands hike to with great effort. Some of these hikers are completing the last few yards of the Appalachian Trail, which begins at Springer Mountain, Georgia. Whew! Makes my feet sore just to think about it. As one hikes the section of the trail shown in this photograph, they must cross an area that has been referred to as "The scariest hiking trail east of the Missis-

sippi." The reason for this daunting reputation is that the ground falls off precipitously on both sides of the trail.

So what mountain is this, and what is the name of this forbidding trail? The trail is famous enough that L.L. Bean even named one of their hiking boots after it. If you're a beginning hiker, you might not want to *cut* your teeth on this particular section of trail.

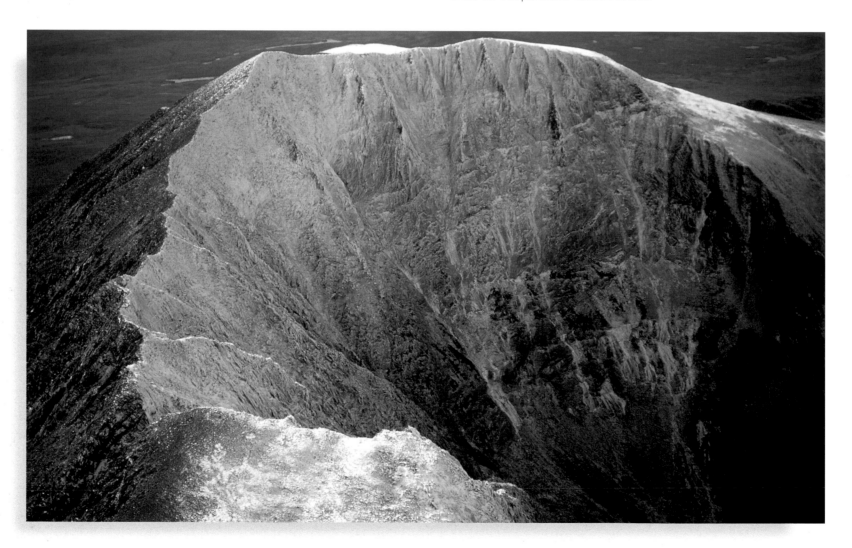

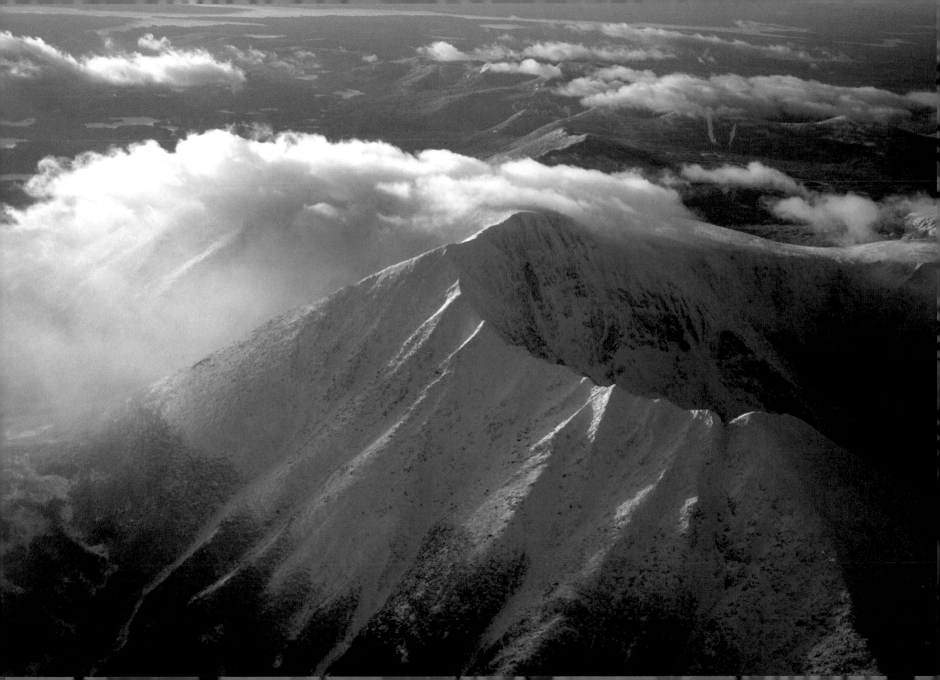

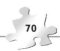

hese two images are both of the same lake. The massive outcropping soars 700 feet above the lake and is the dominant geological feature for miles around. Interestingly, Native Americans traveled long distances to this site to obtain the flint-like rhyolite, a preferred raw material in making stone tools and weapons.

Named for a mountain that cannot be seen from her deck, the steamboat has been plying her trade since 1914. She can carry up to 150 passengers, is 110 feet long, and in her time hauled everything from livestock to railroad equipment, even towed pulpwood rafts. In her early years, she was a primary means of transportation in this area, before an adequate road system was built. Now, her summer days are spent giving tours of the lake, and she is frequently chartered by groups looking for a unique experience in one of Maine's most wild and beautiful regions.

*So, what lake is it? What is the name of the massive outcropping? And what is the name of the steamboat?*

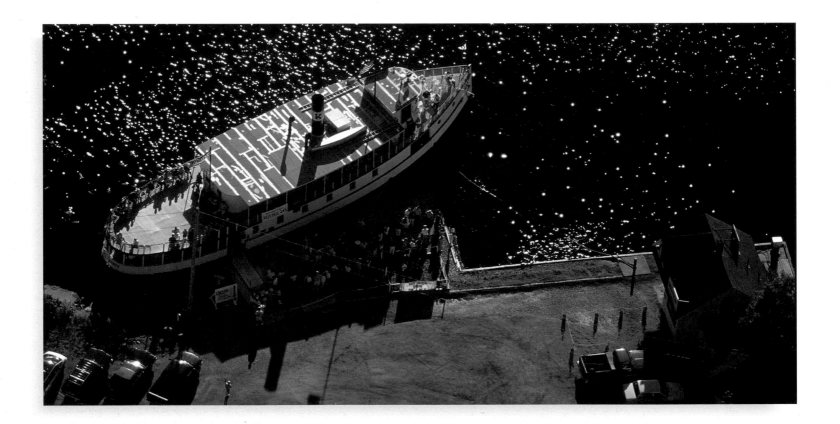

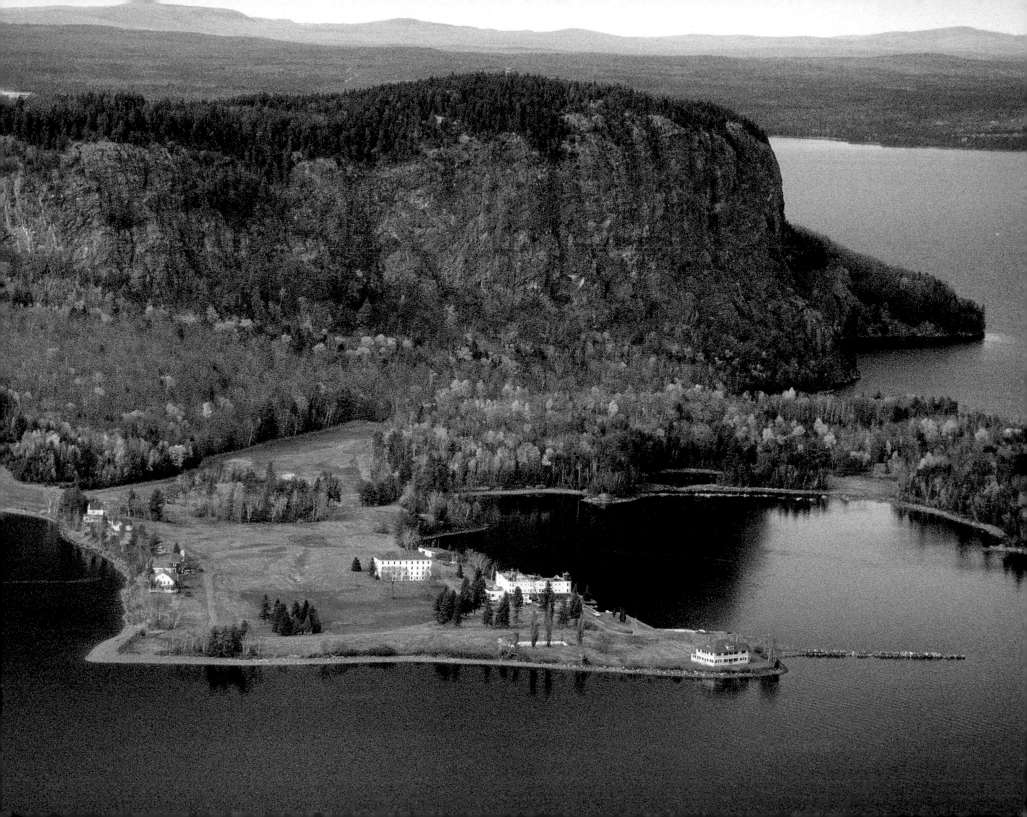

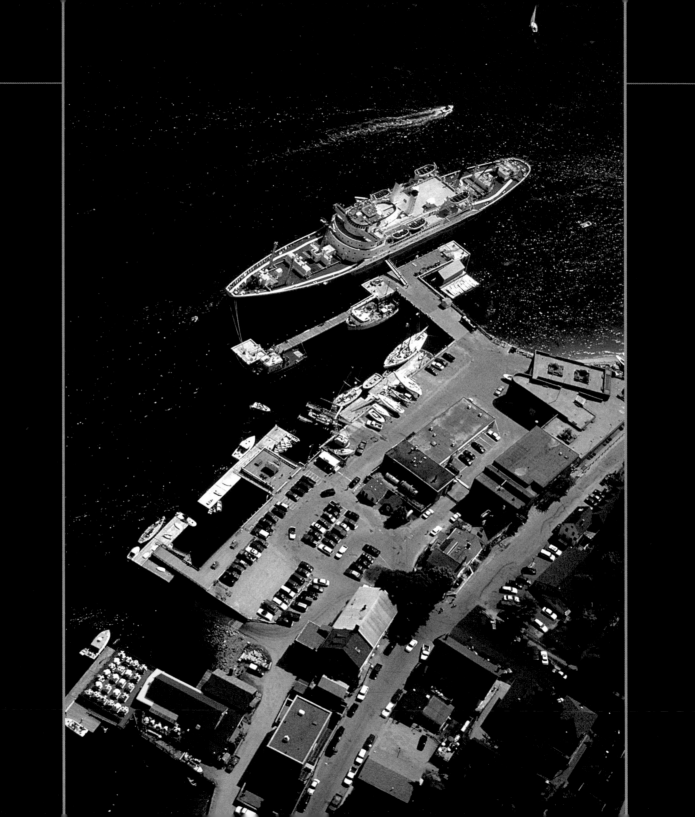

**T**ake a good look at the ship moored here. She's not a cruise ship, at least nothing on the order of the gleaming white palaces that slide in and out of Portland and Bar Harbor on a frequent basis. Nor is she an oil tanker, or a military vessel—according to her paint, anyway. So what is this ship for? It is costly to run and maintain a ship of this size, especially if it isn't used for hauling passengers or cargo.

She isn't in any of Maine's commonly recognized ports. Not Portland, nor Belfast, nor Bar Harbor. The Navy gets its supply of young officers from NROTC and the Annapolis Naval Academy, but the institution that owns this vessel trains young men and women to become the ships' captains and officers of tomorrow for a vast merchant fleet that moves the world's goods.

*What is the name of the institution, and where in Maine is it located?*
*Bonus: The ship in this photograph has been replaced by a newer, larger training ship. What is her name?*

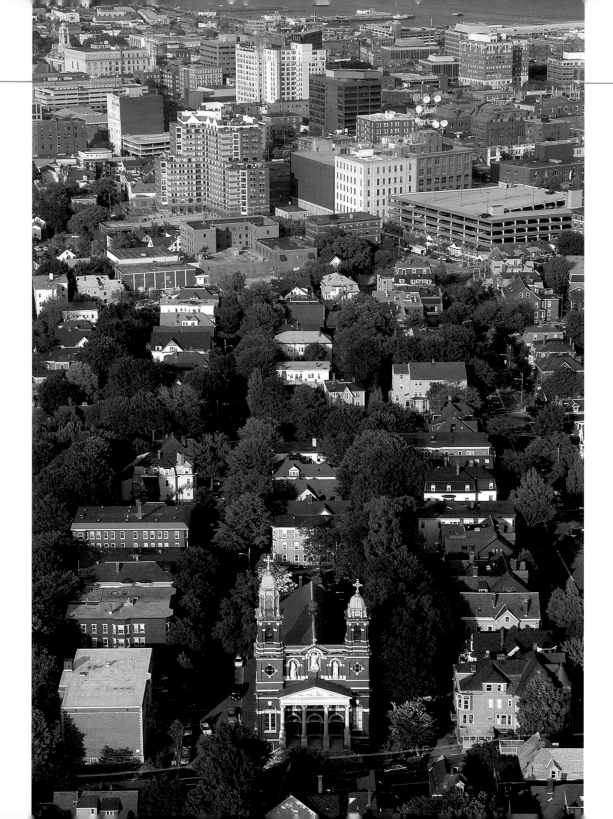

A few years back, this city had the promotional jingle: "It's a lot of fun, for a little city." Of course, it's only a "little" city compared to Boston or other out-sized metropolises. It is actually the largest city in Maine. So, yes, if you guessed Portland, you are correct. And, actually, it is a lot of fun ... for a city of any size. It is also a vital and busy port and an increasing number of cruise lines have made Portland a regular stop for their ships. And the *Queen Mary 2* at anchor off Fort Gorges is a sight you won't soon forget.

But you're not getting off that easily. Do you also know the name of the church that sits so staunchly in the bottom center of the photograph? You may need to do some research. And do you happen to know the Native American term for Portland, which means "shaped like a great knee?"

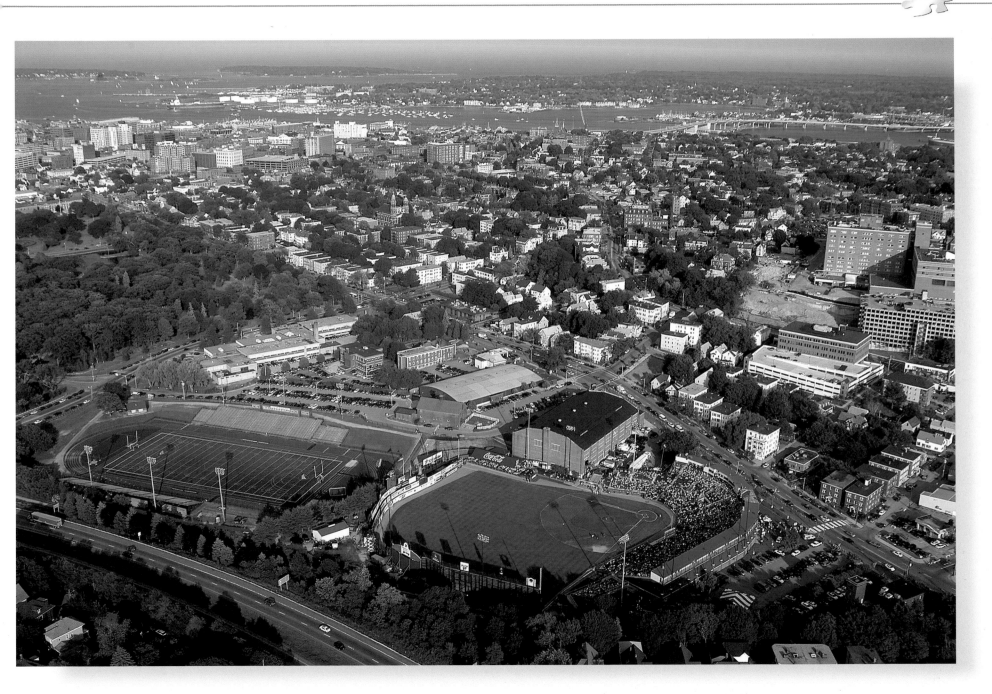

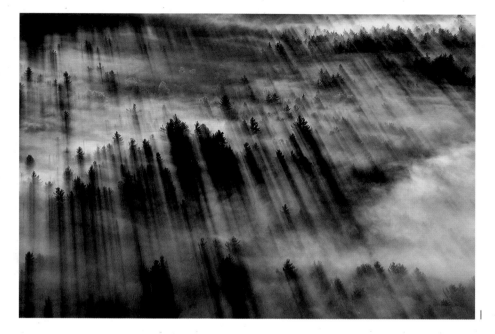

1

2

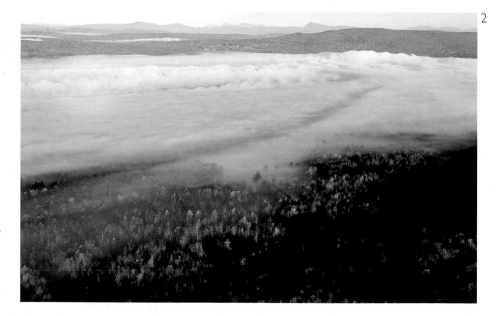

**M**aine is a great place to encounter lots of different fog conditions. The coast is quite famous for its marching fog banks that can swirl in and envelop the unwary with little warning.

So, what is fog? It has been described simply as "clouds on the ground," but as a weather phenomenon it's a bit more complicated than that. The challenge here is to describe what type of fog appears in each image.

Here is some information on fog that might help you. There are four primary kinds of fog:

~ **Radiation fog**—a.k.a. "ground fog" is formed on clear nights when there is a shallow layer of moist air, topped by a layer of drier air. The air nearest the ground cools off, and becomes saturated—the so-called "foggy bottom."

~ **Upslope fog**—in which a volume of moist air rides up a slope until it is above the "dew line," and its vapor becomes droplets.

~ **Evaporation or mixing fog**—which happens when a mass of cold air settles over relatively warm water, causing the evaporating molecules of water to saturate into fog.

~ **Advection fog**—forms when warm, moist air moves over a cooler surface, such as a cold body of water.

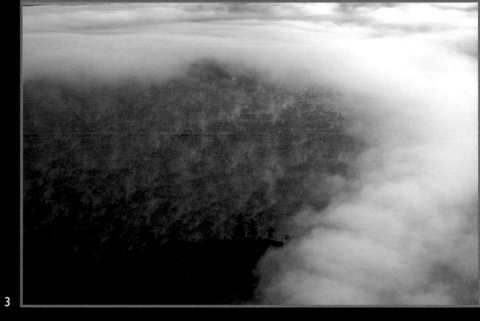

3

4

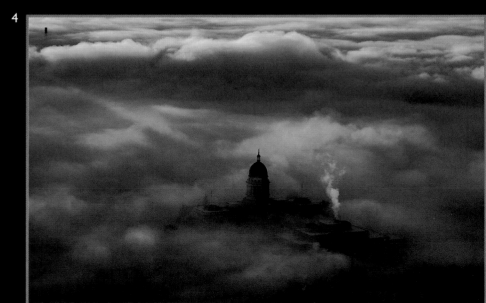

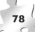

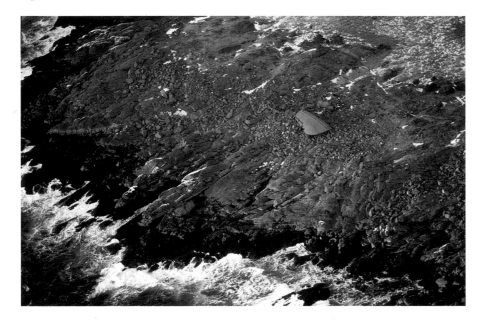

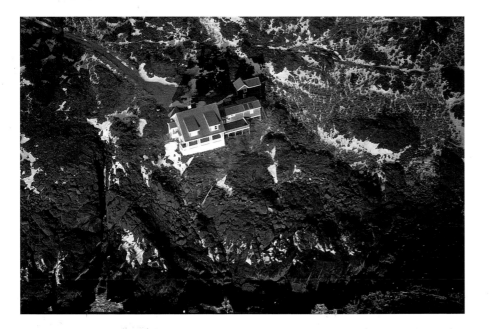

There are literally thousands of shipwrecks—from earliest seafaring times all the way to recent history—on or near the Maine coast. There even lies the hulk of a German U-boat in the depths off Portland. But there is only one wreck that is sitting high and (usually) dry within a short walk from the summer home and studio of a well-known artist.

During a storm on November 2, 1948, the *D.T. Sheridan*, a 110-foot ocean-going tug, ran into trouble —on a rocky piece of Maine called Lobster Point.

Curiously, there is another *D.T. Sheridan*, and it also became a shipwreck, but she's resting under 85 feet of water in Tampa Bay, Florida. Maine's *Sheridan* rests well above the water, her rusting steel bones exposed to the ravages of wind, salt, and time. She is becoming less of a presence every year, and eventually there will be nothing but a few red scraps of rust on this spot.

As for owner of the nearby studio: He has painted his surroundings with the same expressive sense of graphic form and mood as his father and his grandfather before him. He also painted the official White House portrait of John F. Kennedy, and he seemingly has a fondness for painting barnyard animals, seagulls, and ravens.

Okay, it's an island—that you can see from Pemaquid Point—and a summer artists' colony.
*So, where are we, and what well-known artist works near the wreck?*

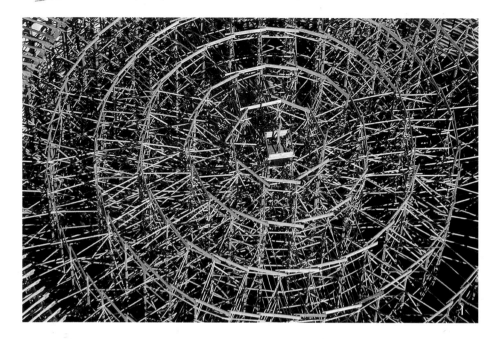

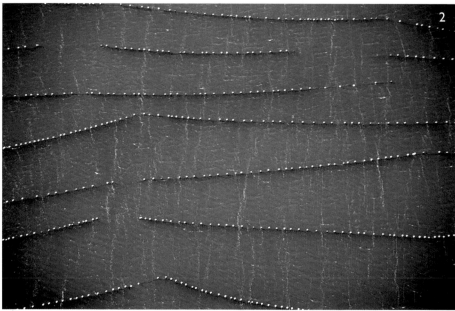

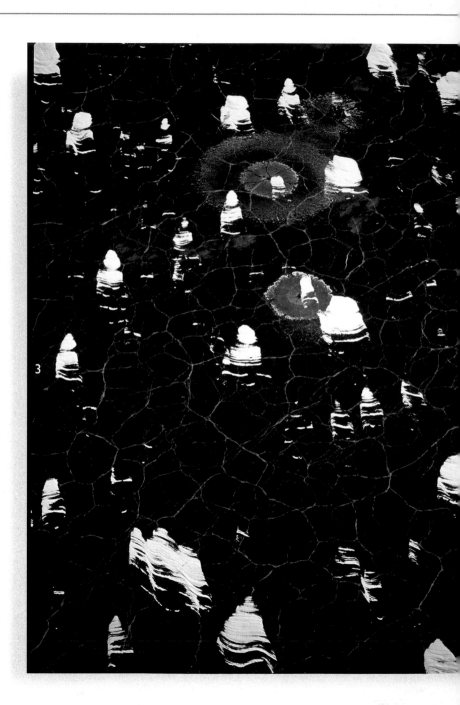

ere are four images that we have chosen because they are not only visually appealing, but also seem to be visual "riddles" at first glance.

The first one—of a maze of lumber that looks like an immensely detailed mandala—is in Topsham. If you look closely, you will see that the boards have been nailed together in a way that tells you they will be disassembled at some point. If they were part of a permanent construction their ends and the entire latticework would be carefully joined. So, riddle number one is: why would someone go to the great effort and expense to put this extensive and complicated structure together...only to tear it down?

Number two image looks almost like the little beaded lines on the chrysalis of a Monarch butterfly. It has an appealing jadeite hue and these lines are clearly there for a specific reason. But, what is it?

Third, is a delicate lacy pattern of lines, overlaid by a patchy pattern of what appears to be snow. And there seems to be a cloudy formation in the upper middle. Okay, what are you looking at, and how do you know that?

Number four, we see a pattern and odd brown "blossoms" in the middle of each segment. If you can say what those are, you will almost certainly have an idea what this place is and what it does. Take a very close look at those blossoms, especially the middle of them.

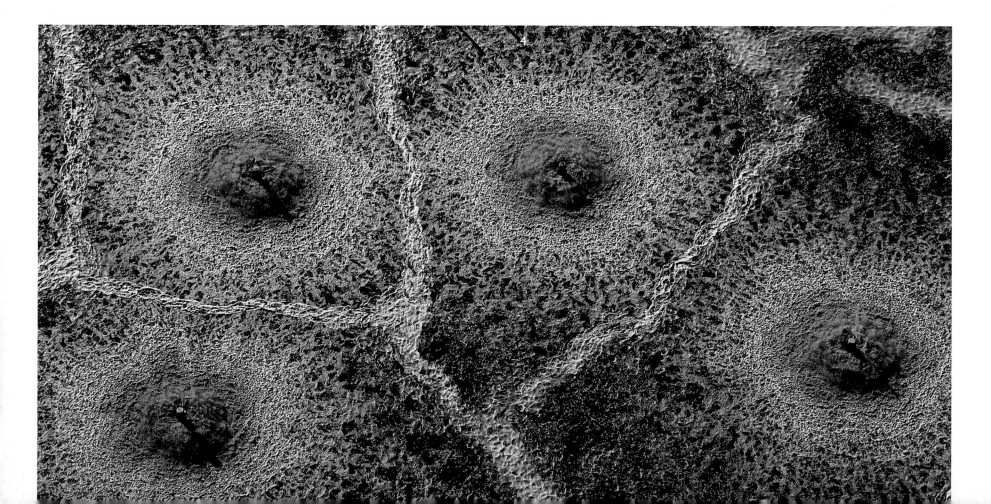

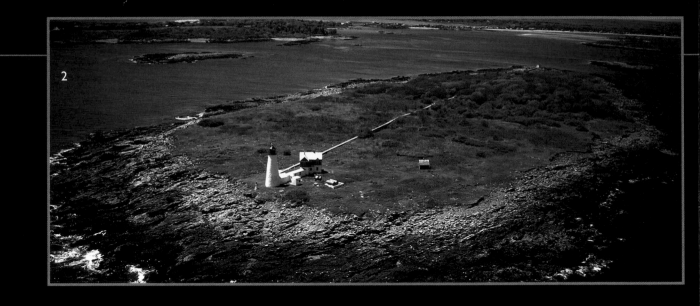

2

1

F ew structures have such universal appeal as lighthouses. If you ask most of the photographers who record the Maine coast on an ongoing basis, they will almost certainly tell you that lighthouses are their most popular images. They are uniquely iconic, standing on a prominent place, near the edge of the sea. They are sentinels of a dangerous and foreboding place, guiding those who have lost their way to safe harbor and home. For this reason, they have been chosen to symbolize a wide variety of human undertakings, from insurance companies to movie production companies, and even the need for spiritual faith.

Of the 68 lighthouses on the Maine coast, we have selected these four because they are each very distinctive and beautiful in their own right. Name all four.

Clues:

Fig. 1: The long quay, built of large blocks of cut granite, is a primary feature of this lighthouse that guards the entrance to a busy commercial and recreational harbor. The quay is not merely a way of getting to the lighthouse, but is also a breakwater that makes the harbor a much calmer place when a Nor'easter comes howling.

Fig. 2: This island lighthouse is the only one that has a walkway the entire length of the island, from the landing to the house. It was recently the beneficiary of a complete refurbishment, and it even has a pool nearby.

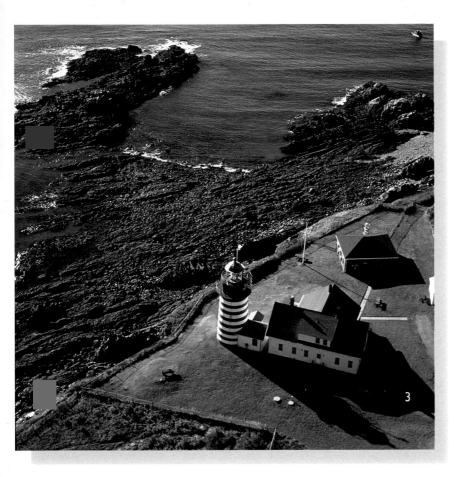

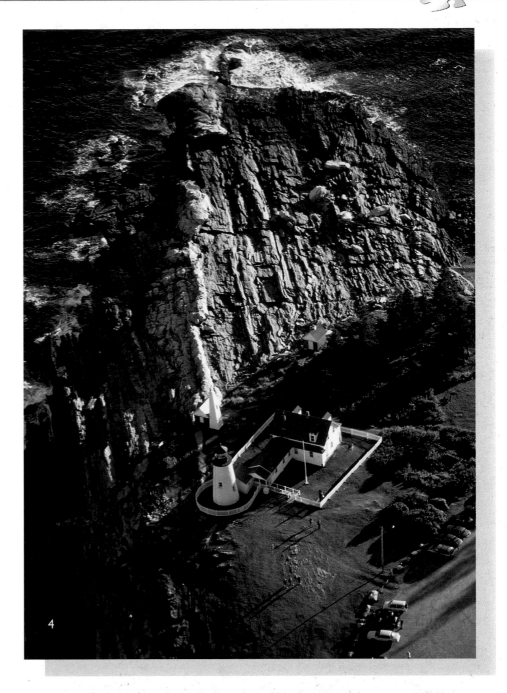

Fig. 3: This is perhaps the most pictured lighthouse of all. It was, in fact, on a U.S. postage stamp, where it was incorrectly pictured with 12 instead of its actual 15 red stripes. It is also not quite as old as the lighthouse at Portland Head, but it was built in 1806, and is on the easternmost point of the United States.

Fig. 4: The parking lot at this lighthouse is usually crowded during the warm months. It is also a very popular photographer's subject, and the rocky shore extending beyond it is a wonderful place to climb about, or simply to sit and look out at Monhegan Island and the sea.

Chester Greenwood was born here in 1858. His early years seem to have been somewhat undistinguished, having dropped out of grammar school, but young Chester apparently had bigger fish to fry—and cold ears. At age fifteen, in 1873, he invented the earmuff. People with warmer ears have been thankful ever since. In 1977 the Maine Legislature felt so grateful they declared December 21st Chester Greenwood Day. There's even a parade on Chester's day, although I am just a little mystified as to why it was sometimes held on an earlier date. Maybe they thought it would be too nippy by the 21st, but—wait a minute—aren't they all going to be wearing earmuffs?

Today, there is a branch of the University of Maine here, and there is a concentration of the arts that is playing a central role in re-defining this town's and the surrounding area's identities. It is even being referred to as "the Arts Belt."

*Okay, what is the name of this town, and in what region of Maine does it lie?*

*Hint: Although this area is not quite as focused on agriculture and manufacturing as it once was, farming remains central to its identity.*

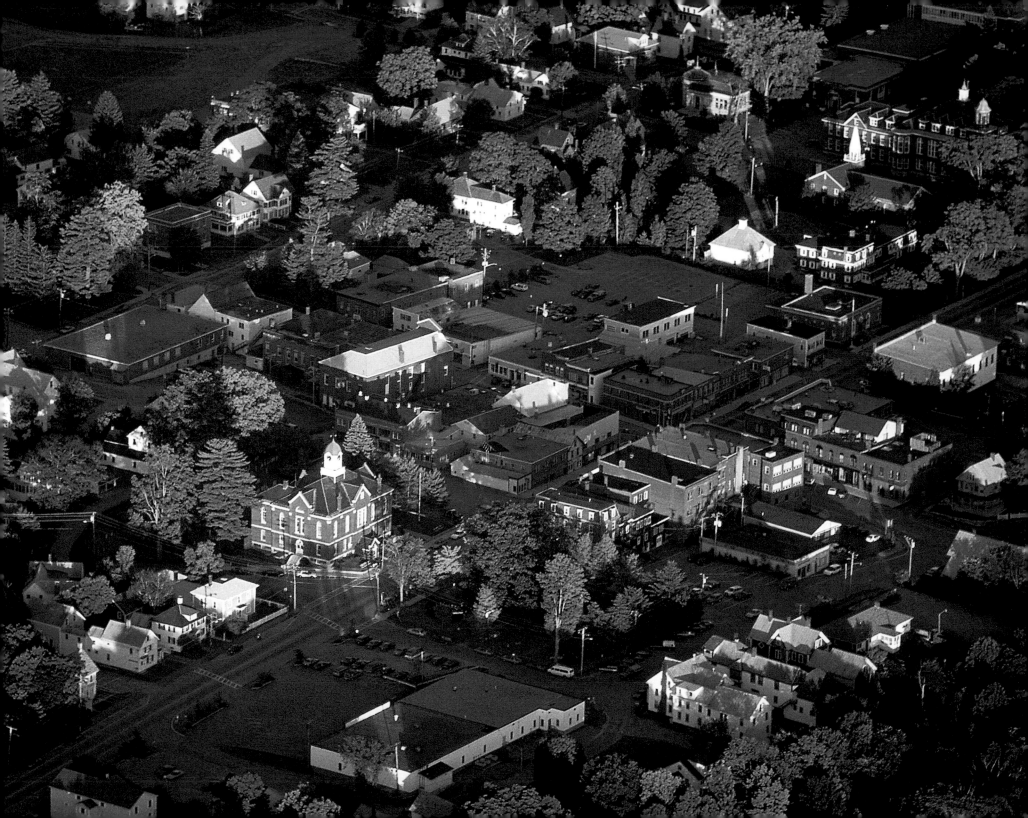

A close examination of this cluster of buildings reveals that it is too large to be a family farm, yet rather small to be a town. In fact, it is a "community." And it traces its roots back to 1747, in Manchester, England. One of a dozen and a half such settlements, this one was initiated in 1783 by an intrepid group of Christian missionaries calling themselves "The Society of Believers," who practiced the dictum, "Hands to work; hearts to God." This is the last remaining active community of its kind.

In addition to living their faith all these many generations, the members of this sect have also left their mark with their remarkable gift for simple and elegant design. In areas as diverse as furniture and woodstoves, they created designs that are referred to with the name of their sect.

*What is the name of the sect?*
*And what is the name of their community?*

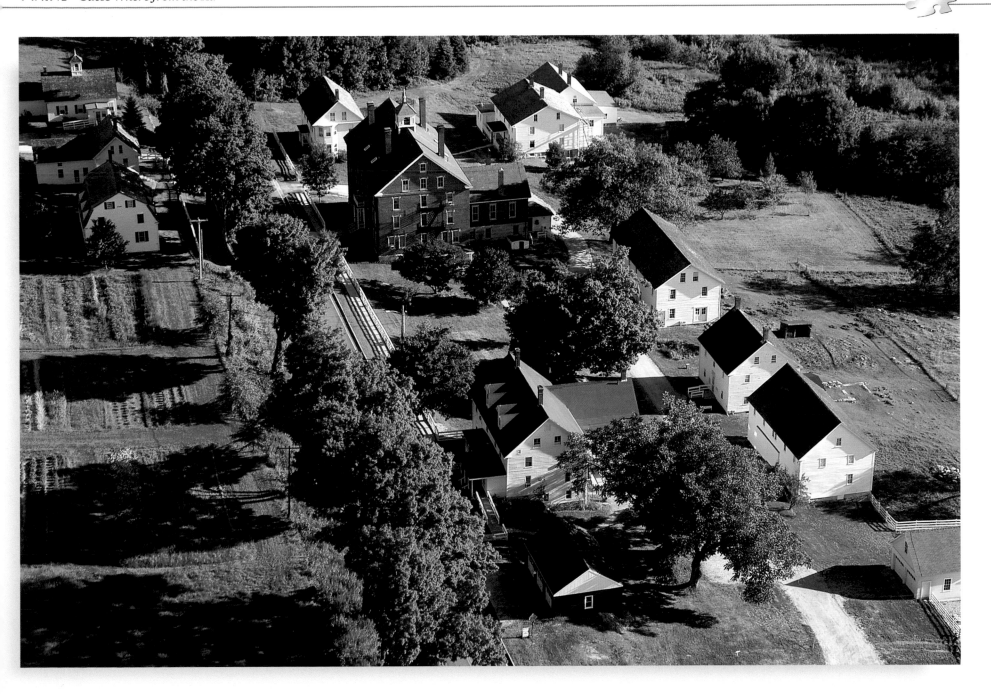

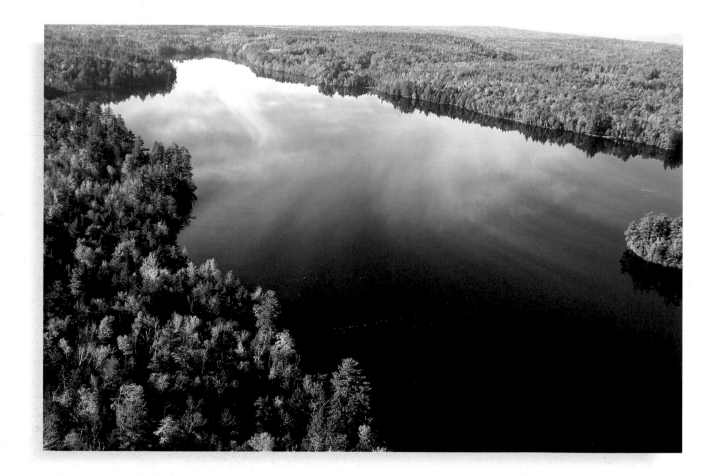

ere are two images that may at first seem unrelated in any obvious way. Because so much of Maine's north country is either inaccessible by road, or can be reached only with great difficulty, float-planes have been popular here since their inception. With the ability to take-off and land on water, suddenly the most remote and uninhabited lakes become a sportsman's paradise. Fishing and wilderness camping in such places are experiences that can transport one back to the time when Maine was nothing but a vast untouched wilderness.

The image with all the float-planes was taken at an annual float-plane "fly-in." There is very likely no place else in the country where a person will see so many float-planes coming and going at the same time. Okay, where is this fly-in held?

The second image is mysterious for another reason. As he approached this lake to land, an experienced float-plane pilot would regard this beautiful fall scene with a distinct sense of discomfort. Why?

*Hint: it has to do with the complete absence of even a slight breeze.*

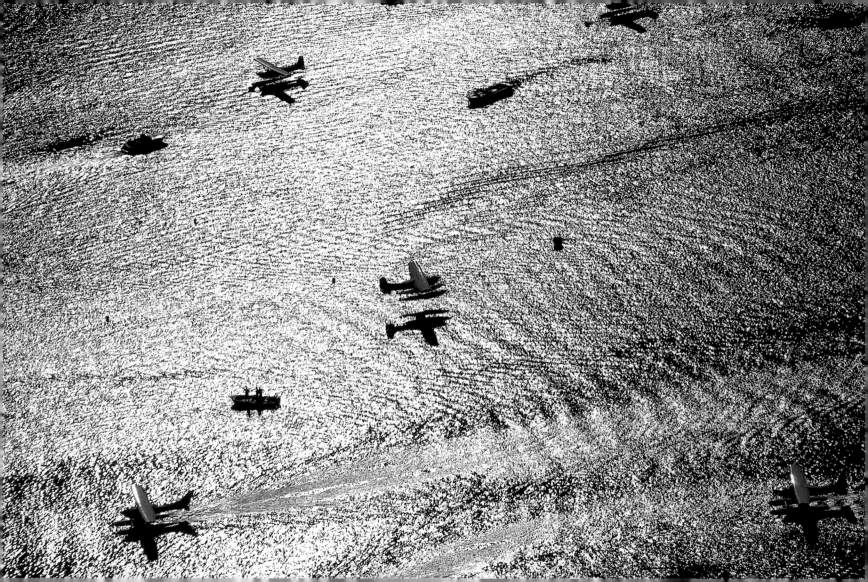

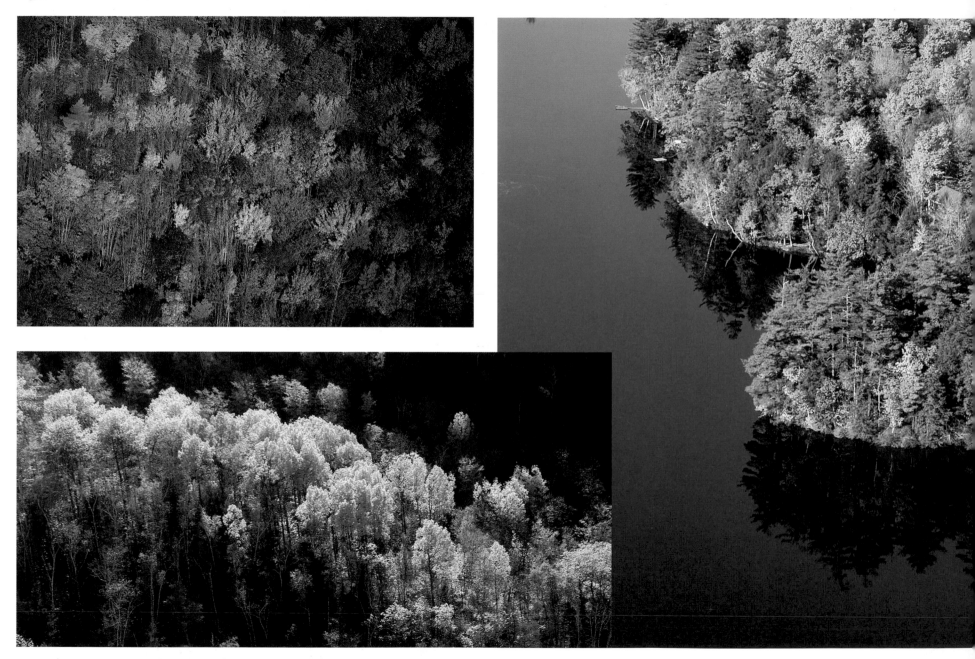

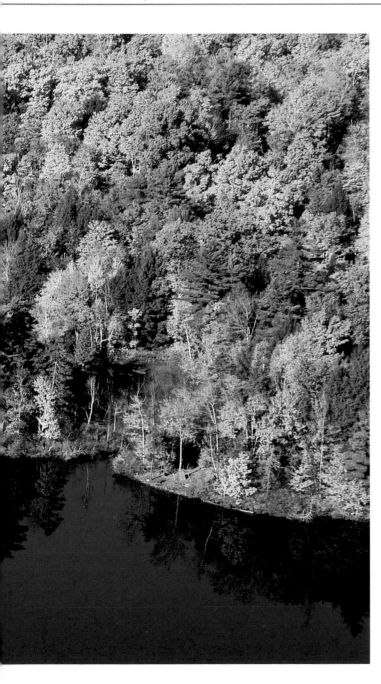

**E**ach year, when the leaves begin the slide from summer green to their crescendo of intense reds, oranges, and yellows, it is as if I am seeing it for the first time. It just seems miraculous to me. But, since childhood, I have also wondered how this happens.

In my high-school biology class, the teacher tried to demystify the phenomenon of leaves turning bright colors. He explained that the autumn hues are in the leaves all summer, but hidden by the little packets of chlorophyll, called chloroplasts. As the days get shorter and the nights colder, the chloroplasts finally give up the ghost and the underlying brilliance is exposed.

Well, it turns out it isn't quite that simple. In fact, it is only just recently that scientists have discovered that the yellow (a substance called *carotene*) is there all summer, but the red (caused by molecules of a substance called *anthocyanin*) appears just in the nick of time to perform a function after the chlorophyll is gone.

One theory is that the red compound, (*anthocyanin*) acts as an ultraviolet blocker, protecting the leaves from sunlight in the absence of the chlorophyll. Another is that it has a chemical role to play, as an antioxidant that protects the leaf cells from damage due to trauma that otherwise would cause an excess of hydrogen peroxide.

*So, the mystery is: what does the red compound in leaves do, and what triggers its appearance each fall?*

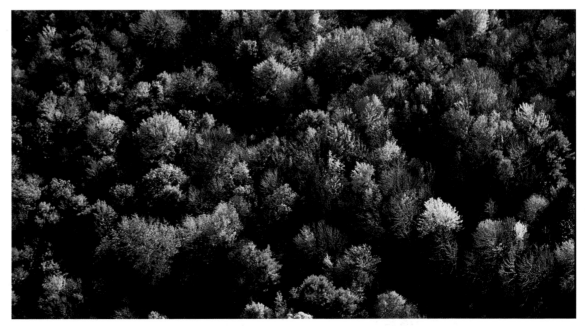

## About the Author

From an early age Murad Saÿen has been an artist. Over the decades he has been a painter, photographer, craftsman, and writer. Although they met as fellow photographers, it was shortly after reading Murad's novel, *Above and Beyond*, that Chuck Feil invited Murad to write the text for this book.

Having lived in the foothills of western Maine for the last 29 years, Murad has brought his own experience and his love of Maine to this book.

Here is a personal example of a mystery that has held Murad's attention for all these years of wandering Maine.

*"Sometimes, it feels like we're in such a rush to get somewhere— anywhere—that we forget to stop along the way and bask in what makes the journey worthwhile.*

*It is my profound sense that we need to feed our spirit just as we do our body. As an artist for my entire life, I have looked to my surroundings for sustenance.*

*And, the one enduring answer that has come to me, again and again, has been in the form of a clue. To my great delight, Maine is a place where this evidence is found in abundance almost everywhere I look. When I see this essence—in even its simplest and most raw forms—it often brings tears to my eyes and a feeling of deep contentment."*

Have you got it yet?

Okay, here's a great hint: science has been unable to really explain why it is such a powerful force in our lives, but everybody—with minor exceptions—perceives it readily, at first glance.

Take a good look at the accompanying image, and ask yourself why the farmer didn't want to cut down that lone tree in his field; why he was willing to mow around it for his entire life?

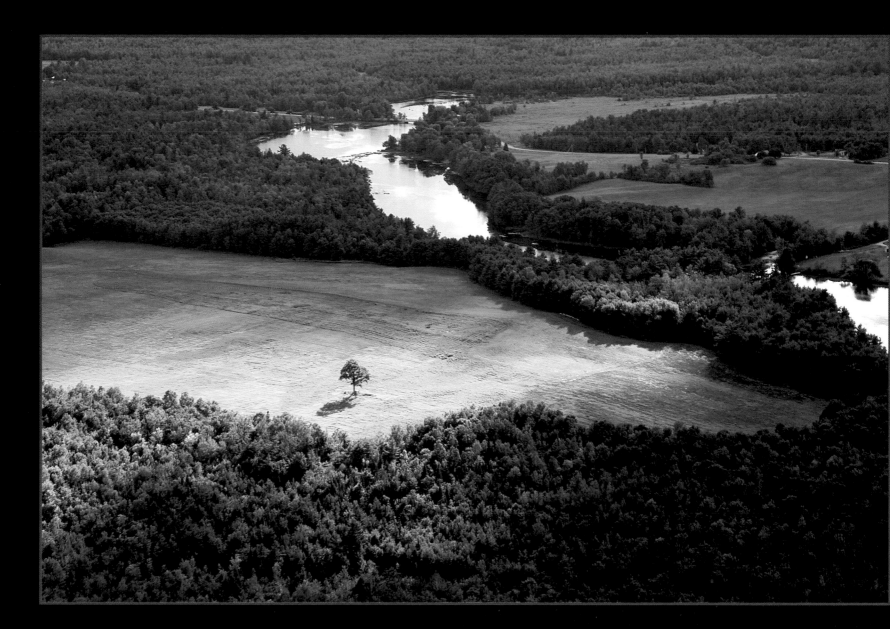

# ANSWERS TO THE MYSTERY PHOTOS

*The correct answers are found by matching the page numbers throughout the book with the numbered pieces below.*

 **6** This aircraft is called an autogyro, a.k.a. gyroplane or gyrocopter.
*An interesting aside*: all the aerial pictures in this book were taken by Chuck Feil, using the aircraft that you see. He has flown "Rooty Kazooty"—actually an RAF 2000, made in Canada—in all of the lower 48 states; and yet, even at airports, most of the folks who work on planes and provide services have not seen this type of aircraft before.

 **8** Roxmont is the home of Down East Books, and is located just south of Rockport, on Route 1.

 **10** The construction of Portland Head Light was authorized by George Washington and begun in 1787.

**12** Old Orchard Beach.

**14** This is the town of Stonington, on Deer Isle.

 **16** Popham Beach. Nearby is historic Fort Popham.

 **18** The annual Windjammer Days festival is held every June in Boothbay Harbor.

 **20** The chapel is on the campus of Bowdoin College in Brunswick; and the basilica is Saints Peter and Paul, in Lewiston.

**22** This is the annual Great Falls Balloon Festival that takes place in Lewiston and Auburn each August.

**24** The town of Rangeley.

 **26** It is a dry-dock. The ship is assembled inside the dock, which is then sunk beneath the vessel, allowing it to gently come afloat.

 **28** Cadillac Mountain, in Acadia National Park.

 **30** Built in Australia, *The Cat* is different from most ferries in that she is a catamaran. This hull design allows her to zip between Portland and Yarmouth, Nova Scotia, at about 55 miles per hour. The cruise ship is leaving Casco Bay and was visiting Portland for the day.

 **32** These are "Boom Piers" (seen here on the Kennebec River), which were used, along with the log booms, to separate each lumber or paper company's logs coming down river into the appropriate holding area.

 **34** GPS (Global Positioning System) is used and every mooring is logged into the harbormaster's computer by its coordinates.
For those less technically inclined, there is also a grid system, in which the anchorage is divided into sections, each designated by a letter, and containing about 150 moorings.

 **36** This is the Androscoggin River, also known to her friends as the "Andy."

 **38** Henry Knox was the man who built Montpelier and after whom this fortress was named.

 **40** It is Belfast, in Waldo County.

 **42** This is Ram Island Light and it is visible across the channel from Portland Head Light.

 **44** The Desert of Maine is located in Freeport.

 **46** Welcome to Wiscasset, on the Sheepscot River.

 **48** The fishing community is Port Clyde, and its lighthouse is called Marshall Point Light. The island serviced from Port Clyde is Monhegan.

 **50** The more one looks into it, the more one realizes that nobody really has the last word on this. It all depends on whom you ask.
*Bonus answer:* "Spring tides" and "neap tides" both occur at least once a month. A spring tide occurs when the earth, moon, and sun are lined up in close to a straight line and therefore exert the greatest gravitational pull on each other. During a spring tide we witness the lowest low tide and the highest high tide, producing the largest range of tides. Neap tides occur when the alignment of the moon is off to the side of the imaginary line that connects the center of the Earth with the center of the sun. When the moon is

farthest off to the side of this imaginary line, the gravitational pull of the moon is weakest, thereby producing the smallest range of tide, so that we see the highest low tide and the lowest high tide.

52 This record storm occurred in the winter of 1998 and has been called The Ice Storm of '98. Crews came from as far away as Hawaii to repair the electrical grid, which had been largely devastated.

54 Great Beach on Roque Island.

56 This is the Carrabassett Valley, home of the town of Kingfield and Sugarloaf Mountain.

58 The camp is called Castle Island, and Long Pond is in the Belgrade Lakes region of Maine.

60 These are all photographs of Maine estuaries—areas where rising ocean tides meet freshwater currents at the mouths of rivers.

62 Maine is famous for its wild blueberries, which grow in barrens—rocky places rich in the acidic soils blueberries need to thrive, but which also largely require that the crop be hand-picked.

64 This is the town of Camden.

66 It's a "cribstone" bridge connecting Orrs and Bailey islands.

68 The mountain is Mount Katahdin, Maine's tallest mountain, in Baxter State Park. The trail, which runs along the top of a sharp ridge, is called the "Knife Edge."

70 The place is Moosehead Lake, the steamboat is the *Katahdin*, and the large rock outcropping is Mt. Kineo.

72 The vessel—called the *State of Maine*—is moored in Castine, where it is owned and used by the Maine Maritime Academy as a training ship.

74 The church is the Sacred Heart Church, on Sherman and Mellen streets. The original Native American name for Portland was Machigonne.

76 1: up-slope fog.
2: radiation fog . . . you can see how the name "foggy bottom" derived.
3: advection fog . . . caused by air moving over a body of water.
4: evaporation, or mixing fog . . . around the state capitol in Augusta.

78 The *D.T. Sheridan* is wrecked on Monhegan Island and the island's most famous artist is Jamie Wyeth.

80 1: is a form for pouring the concrete top on a storage tank.
2: is a maze of off-shore fish nets.
3: is the frozen surface of a lake.
4: is an aeration pond at a paper mill.

82 1: Rockland Breakwater Light.
2: Wood Island Light, near Biddeford Pool.
3: West Quoddy Head Light.
4: Pemaquid Point Light.

84 This is the town of Farmington, in Franklin County. It lies about 40 miles north and slightly west of Lewiston/Auburn. The region is often referred to as either the foothills, or the hills and lakes district.

86 The Shakers. Their community is Sabbathday Lake.

88 The float-plane fly-in is held each September at Greenville. Landing on a mirror-smooth surface is hazardous because of the pilot's lack of depth perception.

90 It remains an unsolved mystery. Scientific research has been unable to answer this question . . . so far.

92 The mysterious quality we call Beauty.

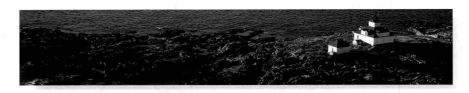